HAUNTED
PUT-IN-BAY

WILLIAM G. KREJCI

Haunted
America

Published by Haunted America
A Division of The History Press
Charleston, SC
www.historypress.net

Copyright © 2017 by William G. Krejci
All rights reserved

First published 2017

Manufactured in the United States

ISBN 9781625858528

Library of Congress Control Number: 2016961745

Notice: The information in this book is true and complete to the best of our knowledge. It is offered without guarantee on the part of the author or The History Press. The author and The History Press disclaim all liability in connection with the use of this book.

CONTENTS

CONTENTS

ACKNOWLEDGEMENTS

.I would like to extend a special debt of gratitude to the following for their kind assistance and support while I was writing this book. First and foremost, I wish to thank Krista Slavicek, my editor, for all of her help, suggestions and patience with me while I worked to get this completed. Thanks is also extended to Abigail Fleming, who worked on the final edits. I would also like to thank Dan Savage and everyone at the Lake Erie Islands Historical Society Museum for the terrific photos and resources; Maggie Beckford, likewise, for the use of her personal photo collection; the staff at Perry's Victory and International Peace Memorial for their guidance; Jeff Helmer, Barbara Fearon and Kathy Holbrook for their encouragement; Charlie Holbrook for the great ideas; Steve Elliott for helping me with a few ideas of who I should talk to; Chip Duggan for pulling my leg when I asked him if he had any great ghost stories; Philip Boyles at the Park Hotel for the hours of help you gave me; Bob and Judy Bransome, Kelly and the staff at Ashley's Island House; Nancy Cruickshank, Ohio Sea Grant and the students and staff at Stone Lab for sharing what you know about the lighthouse; Jackie at the Country House; Terry Heidenreich, Robby and Mary Lou at the Put-in-Bay Winery; Melinda Myers and Bridge Francis for sharing your experiences at the Crew's Nest; John Domer, your stories are priceless; Hippie Jerry, more of whose stories I'm looking forward to hearing; Artie Boyles, Arthur Boyles Sr. and Denise Kaczmarek, I never could have written the chapter on Joe's without your insight; Mike Jones, you didn't really contribute much of anything, but you're still a great guy; the staff and

patrons of Joe's Bar, who helped me to get started with this; Don Thwaite for sharing those great stories about the Skyway; Tommy Dailey, Kylie Simonds, Khloe Zolgharnain, Ken Bodie and Jessica Krueger at the Put-in-Bay Brewery and Distillery, stop talking about Benny; David and Bobby Hill and Sean Koltiska, I really can't thank you all enough; Andy Christensen at the Reel Bar for sharing what you know about the place; Dan Mercurio, Marisa Rence and Eric Booker at Hooligans for your assistance and support; Tim Niese Jr. for taking the time to share your experiences; Kelsey Arnold and Blake at T&J's Smokehouse; Bret Klun at the Keys; Mary and George Krejci, for always being there for me; and finally a huge thank-you to the entire community of Put-in-Bay, Ohio. You really make me feel at home.

INTRODUCTION

Fun in the sun, a quiet weekend getaway, live music, excellent fishing, American history, scenic caves and incredible nightlife—these are some of the images that we conjure in our minds when we think of Put-in-Bay, Ohio. What eludes most people is the idea that many of the places we visit during our little summer escapes from the city hold dark stories of tragedy and misfortune. Ghosts, specters and otherworldly apparitions lurk in the shadows and, in some cases, cause all sorts of disturbances. It's hard to imagine this being the case in such an otherwise cheerful, relaxed and easygoing atmosphere.

In order to understand the stories about to be related, it would be wise to understand the backstory of the location being presented. Let's begin with the name.

Here's the first question that most people ask upon arrival to this little island paradise. Is it Put-in-Bay or is it South Bass Island? Herein lies a little confusion. In all actuality, it's both. The formal name of the island is South Bass, and the village located thereupon is called Put-in-Bay. To make matters a little more interesting, the beautiful bay that abuts the village is also called Put-in-Bay, as is the township, which encompasses the islands of South Bass, Middle Bass, North Bass, Sugar, Green, Rattlesnake, Gibraltar and Ballast.

Confused yet? We've only just started.

Put-in-Bay has actually had many names. On some of the earliest maps of the area, it is referred to as Pudding Bay or even Puddin Bay. This gave rise to the idea that the modern name originated from a description of the

muddy bottom of the harbor, which resembled pudding, or the physical shape of the bay, which reminded people of what has been described as a pudding sack, whatever that might happen to be. In all actuality, this was simply a slang on its contemporary name, which was already in use at the time these maps were drawn. The location actually received its name for the harbor, which offered sailors a safe place in which to put their boats to weather out the sudden and severe storms that frequent Lake Erie.

Other names that have been placed upon the island are Put-in-Bay Island, Big Bass Island and even Ross Island, which came from an early caretaker who inhabited the beautiful isle.

Obviously, the first inhabitants of South Bass Island were the indigenous people of North America, though there is little evidence to show that Native Americans actually settled on this island, and few remains or artifacts have ever been found. When Europeans first started to venture into the area, it was noted that the Native Americans primarily used the islands to cross from what is now Ohio into today's Ontario. Along the way, they would stop at these islands to hunt and fish. It is believed that one of the major deterrents for settlement on South Bass Island was the abundance of rattlesnakes.

With the survey of the land west of the Cuyahoga River in 1808, the townships of Ridgeville and Avon (today's North Ridgeville, Avon and Avon Lake) were granted to a U.S. federal judge named Pierpont Edwards, who was a founder of the Connecticut Land Company and owned one-twentieth of the Connecticut Western Reserve. The tracts that he was granted were to measure five miles by five miles each. There arose a problem with this, however. The northern part of Avon Township, which would later become the city of Avon Lake, was missing some land on the eastern and western edges where Avon Point juts into Lake Erie. To make up for this loss of area, Judge Edwards was granted the Lake Erie islands that would later make up Put-in-Bay Township.

In the few short years following Judge Edwards taking ownership of the islands, the United States declared war on Great Britain, bringing these two nations into what would come to be known as the War of 1812. By this point, a few small families had settled on South Bass Island and had even cleared land and brought in a harvest of wheat. Later that year, these settlers were chased off of the island by the British and their Native American allies, and their crops were burned.

Curious to know the state of the islands, Judge Pierpont Edwards sent his eldest son, John Stark Edwards, in the winter of 1812–13 to take possession of the islands and survey the damage that had been done. Unfortunately,

John Edwards would only make it as far as the Marblehead Peninsula. He died there from fever on February 22, 1813.

With the British now in control of Lake Erie, the United States lost its only supply routes to the Northwest Territory, which would one day become the states of Michigan, Illinois, Indiana, Wisconsin and Minnesota. In order to retake this territory, the United States needed to construct its own fleet of vessels to challenge the British squadron on the lake. This incredible feat transpired in present-day Erie, Pennsylvania. It was there, at its completion in the summer of 1813, that a young master commandant named Oliver Hazard Perry took command of the newly completed American squadron and sailed it to the western end of Lake Erie. As his base of operations, he chose Put-in-Bay. From here, he could sever the British supply lines to Fort Malden and Amherstburg on the Canadian side of the lake and readily engage the British squadron should it choose to leave the safe harbors on the north side of the lake.

On the morning of September 10, 1813, with their stores running low and rations down to about one day's supply, the British were forced to sail out and meet the American squadron stationed at South Bass Island. The Americans, fighting against an unfavorable wind, spent hours tacking their vessels back and forth just to attempt to get them within firing range of the distant British ships now coasting along to the east of West Sister Island. Finally, at around ten o'clock that morning, the wind shifted and gave the Americans the advantage of engagement, technically known as the weather gauge. It was at this that Oliver Hazard Perry raised his famous battle flag, which bore the words DONT GIVE UP THE SHIP. In less than two hours' time, the Americans brought their vessels into range and cannons began to ring out from both sides. A destructive force of cannonballs and musket fire was exchanged for the next two and a half hours.

To Perry's dismay, and for reasons still debated today, the second in command of the American squadron, Jesse Duncan Elliott, kept his vessel, the brig *Niagara*, out of the action for the majority of the battle. This allowed the two main British fighting ships, the HMS *Queen Charlotte* and HMS *Detroit*, to concentrate their entire firepower on Perry's flagship, the U.S. brig *Lawrence*. Eighty percent of Perry's crew aboard the *Lawrence* was either killed or wounded.

At about 2:30 p.m., Perry himself aided in firing the last working carronade on his vessel. A moment later, a cannonball came tearing through and dislodged the gun from its mountings. Now with his flagship a floating wreck, Perry was faced with the idea of having to surrender. That all changed

a moment later when he noticed that his second in command was finally bringing the *Niagara* into close action. In a bold and daring move, Perry called upon five of his men and ordered them into one of his rowboats. He lowered his battle flag and, with it rolled up in his arms, followed them down the ladder into the boat. Barney McCain, James Jackson, Benjamin Dring, John Brown and Ezekiel Fowler then rowed Master Commandant Oliver Hazard Perry perilously through a hailstorm of cannonballs and musket fire to the approaching *Niagara*.

Fifteen minutes later, Perry boarded the approaching brig, sent Jesse Duncan Elliott to bring up the other four gunboats that were still well astern and took command of the vessel. At this, he raised his battle flag and daringly charged the brig directly at the British battle line. Seeing this completely unscathed vessel now coming into action, the British attempted to turn their two ships about and bring their unused guns to bear. Unfortunately, one vessel turned early while the other was trying to advance, and the two ships collided with one another. This left an opening in the British battle line, and Perry took advantage of the blunder. He broke through the line and set up a raking fire across the bows and sterns of the British vessels. This he kept up for about fifteen minutes until just after three o'clock in the afternoon, at which time the British began to surrender one by one.

At last, the battle was over, and the Americans had become the victors of what history would come to know as the Battle of Lake Erie. The victory had come at a high cost. Many lives were lost on both sides, and many more would follow in the days to come. Those enlisted men who had fallen during the battle were committed to the lake in a funeral service held that evening. The fallen officers of the battle, three American and three British, were interred two days later in a small clearing on South Bass Island. The grave site was then marked by a willow tree that would stand for the next eighty-seven years.

With the British no longer in control of Lake Erie, the Americans were now able to reclaim their Northwest Territory. The war would continue for more than another year before peace would come to these nations. Oliver Hazard Perry became a national hero for his deeds that September day on Lake Erie and was eventually promoted to the rank of commodore. Unfortunately, Commodore Perry would only live for another six years. He died on August 23, 1819, from yellow fever while returning from a mission to Venezuela. It was his thirty-fourth birthday.

The U.S. Navy continued to maintain a base of operations at Put-in-Bay until the end of the war. With the 1817 signing of the Rush-Bagot

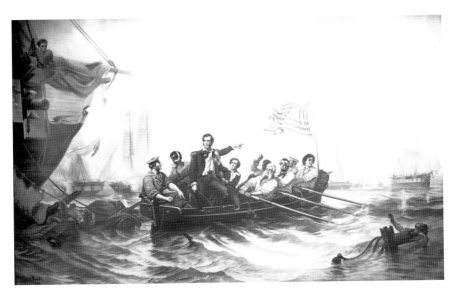

An overly exaggerated and historically inaccurate depiction of Commodore Oliver Hazard Perry making his famous crossing from the *Lawrence* to the *Niagara* during the Battle of Lake Erie, by William Henry Powell, 1873. *Courtesy of the Library of Congress.*

Treaty, which brought naval disarmament to the Great Lakes, the force was no longer needed and almost every naval vessel upon the lakes was either scuttled, scrapped or sold into merchant service.

With peace came prosperity. Judge Pierpont Edwards continued to encourage settlement on the islands. Among those who settled there was a man named Henry Hyde, who arrived at Put-in-Bay in 1818 to work as an agent for Judge Edwards. The year 1823 saw the construction of the first frame house on the island. This was used as a summer residence for the Edwards family and was referred to as the White House and sometimes even as the Manor House. Until then, all of the structures on the island had been simple cedar log cabins. It was around this time that the islands passed into the hands of Judge Edwards's other son, Henry Alfred Pierpont Edwards. The judge would pass away in 1826.

Hyde, with his wife, Sally, and their children, would remain on the island until just after 1830, when Sally passed away at the age of forty-three. The island would see many other caretakers and agents over the years that followed, but none came close to the tenure of Philip Vroman, who arrived in 1843 and would call Put-in-Bay his home until his own death in 1912. Vroman would be regarded in later years as the longest-lived island resident

and island historian. Many of the stories we have today come from his own personal recollections and those of his sons.

Henry Alfred Pierpont Edwards would continue to own the islands until the marriage of his daughter, Alice Edwards, to Elisha Dyer Vinton on October 19, 1853. He passed these island on to them so that they might build a bright future together. As the story has it, however, Vinton was more interested in money than owning islands on Lake Erie. He and his wife put the island up for sale, and it wasn't long before they found a buyer. That buyer was Joseph De Rivera St. Jurjo.

Joseph De Rivera St. Jurjo was born on March 30, 1813, in Barcelona, Spain, to wealthy plantation owners José and Juana De Rivera of Puerto Rico. His parents had been back visiting family when Joseph was born. They returned to their home in Loíza, Puerto Rico, the following year, and it was there that young De Rivera was raised. In 1835, he traveled to New York and there started a sugar- and produce-importing company. Three years later, he was naturalized as a U.S. citizen and became very successful in his business.

Something to note is how his last name is spelled in this book. If anyone should read the plaque in town or any mention of him on any website or in a book for that matter, they may notice that his last name is spelled St. Jurgo with a *G*. This was not the case. His last name was in fact St. Jurjo with a *J*. This is evident from his naturalization records from 1838 as well as his passport application from 1871, both of which bear his signature. In his own time, Señor De Rivera explained the uniqueness of his last name. He elaborates upon it by saying that De Rivera was his father's surname and St. Jurjo his mother's. As was the custom in his homeland, both would be used in this form and order when officially signing one's name. Commonly though, he was addressed as José De Rivera.

After seeing an advertisement in 1854 that listed the islands as being up for sale, José De Rivera traveled to the western basin of Lake Erie to see the beautiful isles for himself. Realizing the potential of the islands, he purchased South Bass Island—as well as the other five in the immediate vicinity—from Elisha and Alice Vinton for $54,500. He noticed at once that the islands had the perfect growing condition for grapes and other produce. The warmth of the lake lent to creating a later growing season for such crops. Thus, he brought in a team of surveyors, divided South Bass Island up into ten-acre lots and sold them to the public. His main target was to bring in German vintners for the cultivation of grapes and the production of wine, a craft that De Rivera himself would work at as well.

Through José De Rivera's civic guidance, the village of Put-in-Bay was officially established in 1877. De Rivera donated land to the community for a church, a school and a cemetery. He also handed over control of the large park in the middle of town to the village. To this day, it is managed by a board of three trustees. Furthermore, this park now bears the name De Rivera Park, in honor of this great community leader. José De Rivera died at Put-in-Bay in 1889 and was buried alone in a tomb in the island's Crown Hill Cemetery. His burial vault sits against the old entrance to the cemetery along Catawba Avenue.

During the years that José De Rivera occupied the island and set it on its course toward becoming an ideal island getaway, Put-in-Bay saw much growth in tourism. Thousands of visitors would be drawn to the island annually to take in its many attractions. At one time there were as many as four caves on the island that were opened to the public, two of which were operated by De Rivera and his family. Visitors would also come to enjoy the history that the island had to share. Many commemorations of the Battle of Lake Erie were held at the site of the old willow tree in De Rivera Park that originally marked the site of the burial of the fallen officers from the battle. This willow tree stood until 1900, at which time it fell over and was replaced by a memorial composed of a stack of cannonballs, which marks the site to this day. Many would also come to enjoy the fine wines that were being produced on the island and to take in the sights, sounds and beverages offered in town, a tradition that continues still.

With all of this tourism came the need for accommodations. Many of these you will read about in the pages that follow, but no hotel could rival the size and elegance of the famous Hotel Victory.

Plans for this elaborate lodging were first conceived in the mid-1880s, with the cornerstone being laid in the fall of 1889. When completed in 1892, the Hotel Victory was regarded as the largest summer hotel in the United States, making it one of the largest in the world. With over 180,000 square feet of living space and 625 guestrooms available, the hotel boasted two dining rooms and could serve up to 1,200 guests at one time. The outdoor swimming pool, called the natatorium, was added to the facility in 1898 and was one of the first coed swimming pools in the country. Even in the late nineteenth century, Put-in-Bay was regarded as a party hot spot.

Transportation to the hotel from the docks downtown was provided by an electric trolley line that skirted Catawba Avenue and made stops at Perry's Cave and Heineman's Winery.

The Hotel Victory continued to operate and accommodate guests until 1919, when on the night of August 14, it was completely destroyed by an impressive fire. The flames were so large that the glow could be seen as far away as Toledo and Detroit. Today, the site of the Hotel Victory is occupied by the South Bass Island State Park. Only small ruins, reminders of the glory days, can be found upon the site. Among these are a small pedestal that once held a statue of the mythical figure Victory. The bronze statue that once graced the lavish gardens around the hotel was melted down for the war effort during World War II. Also to be seen are the ruins of the natatorium, now crumbling and abandoned to the hands of time.

It's a sad fact that the biggest foe on the island is fire. Not to suggest that Put-in-Bay has an inadequate fire department, quite the opposite, really, but more to the point is the fact that many of the buildings on the island are over one hundred years old and constructed of wood. Even the slightest of sparks could set off any number of buildings like a matchbox. Many famous island structures have been lost in this manner, including two hotels that bore the name Put-in-Bay House, the first of these having been built from the old Edwards residence. Also to have fallen to the flames and ashes were the Castle Inn, a fine hotel located close to the Hotel Victory, and the Colonial, a

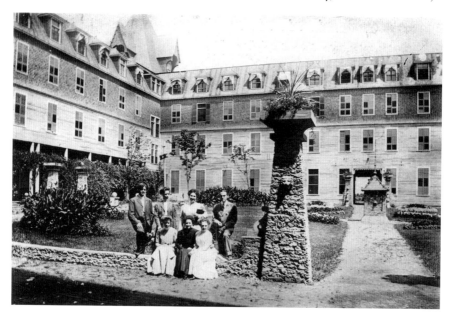

A family gathers for a portrait in the courtyard of the now-lost Hotel Victory. *Courtesy of Maggie Beckford.*

14

grand establishment that was built on the site of the two previous Put-in-Bay Houses in downtown. The latter having burned on Memorial Day weekend in 1988, the site is now graced by the Beer Barrel Saloon complex.

Today, Put-in-Bay is a mecca for tourists, thrill-seekers, boaters and sports fishermen. It is also a haven for those seeking to get away from the rush of city life, if only for a weekend at a time. Visitation throughout the summer months well exceeds 750,000 tourists. During the winter months, it has a population of around 400. People come from all over the world to enjoy its Victorian-era village and to bask in its pristine blue waters. They've been coming for more than one hundred years and they'll continue to come for hundreds more.

So now that we have an understanding of Put-in-Bay's past, we can more easily relate the stories that follow to a location that makes sense.

When it comes to island ghost stories, it can easily be found that many year-round residents have one or two to share. One such resident, who was raised on the island, was very forthcoming.

This story begins one evening in the dead of winter, some years ago, when our storyteller was still a youth. He had been out ice fishing for most of the afternoon and was having some considerable luck that day in bringing in some fish. As the day wore on to evening, a snow squall blew in and visibility was rapidly deteriorating to the point that the subject of this story could no longer see the lights of Put-in-Bay. Having a general idea of the proper direction in which to go, he started off across the ice but soon found himself entirely lost.

Just as he was about to give up hope and attempt to retrace his steps back to the ice shanty, a set of lights appeared in the distance. Growing ever closer, our storyteller realized that these were, in fact, the headlights of a car. As it pulled up, he noticed at once that it was a vintage Ford from the early 1930s. Such cars were common in those days and were still in use for making the trek across the ice from island to island.

The driver, an elderly man, kindly greeted the misdirected boy and inquired as to where he was headed. When it was related that he was trying to make his way back to Put-in-Bay, the driver informed him that he wasn't going quite that far, but could take him close enough. The youth gladly accepted the offer and hopped in. The two talked for a bit, and the man identified himself as (we'll call him *John Ohlendorf.*) The young man had offered Ohlendorf some money or a couple fish as compensation for the ride, but both of these Ohlendorf refused. He did notice, however, that the young man happened to also be holding a bottle of Heineman's

Pink Catawba wine. Ohlendorf suggested that a few pulls from the bottle would suffice. The youth gladly handed over the bottle and told him that he could keep it.

A few minutes later, lights began to emerge through the snow and downtown Put-in-Bay had come into view. Ohlendorf brought his antique vehicle to a halt a couple hundred feet from shore and wished his passenger well. With that, the young man stepped out of the car, thanked Ohlendorf for the ride and continued on foot across the ice, through town, until he reached the safety of his own front door.

Upon walking into the house, our storyteller explained that his father was quite furious at the young man for staying out so late. He had even considered assembling a search party to go out on the ice to look for him. When the young man told his father of the sudden squall and the kindness of Ohlendorf, his father grew perplexed. He explained to his son that John Ohlendorf didn't have any children, let alone any relatives who bore his first name. The young man insisted that this was, in fact, the man's name. The father continued by explaining that John Ohlendorf had driven his Model A Ford through the ice some twenty-odd years earlier. The car was never recovered, but Ohlendorf's remains were discovered a week later. He was accordingly buried at Crown Hill Cemetery near the west shore of the island.

That night, our storyteller went to bed with many questions on his mind as to who the mystery driver could really have been. The next morning, his mind was still buzzing with questions. To prove that John Ohlendorf was dead, the father took him over to Crown Hill Cemetery to show him his headstone. Upon their arrival at the burial site, they were both stunned to find an empty bottle of Heineman's Pink Catawba wine resting at the base of his tombstone.

Our storyteller concluded by saying that if I'll believe that one, he's got a few more.

Obviously, this was a take on the old legend of the ghostly hitchhiker, only with something of a role reversal and an island twist. Of course, there are other stories like this on the island, such as the legend of the Coon Man and whatnot, but the pages that follow are ghost stories directly related to specific sites and structures found across South Bass Island. Nearly all of these have been substantiated by multiple witnesses to events that have transpired in the past and still continue to this day.

It should further be noted that while some people might have an idea as to the identity of who specifically may be haunting these locations, there truly

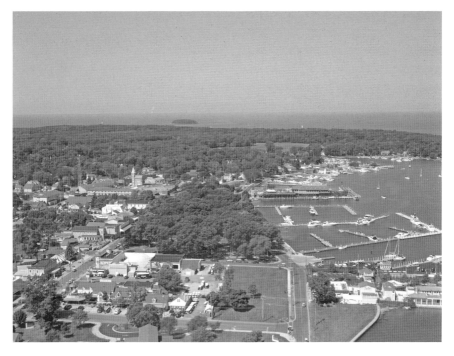

A bird's-eye view of the village of Put-in-Bay as seen from the top of Perry's Victory and International Peace Memorial today. *Photo by the author.*

is no way to know for certain. Put forth will be the stories and histories of these locations, any tragedies that may have occurred and the disturbances that followed. Some locations have given their ghosts names, while others have left that idea open to supposition. While some of those names will be related, as they were by those who were kind enough to share their stories, it's best to remain objective and to keep an open mind to any possibilities.

Finally, this book will read as if you were to take something of a tour of the island. It will start with a check-in at a couple notoriously haunted island lodgings. From there, we'll do a little sightseeing of some famously storied attractions, and will conclude our visit with a night out to a few island bars where beer, wine and liquor aren't the only spirits to be found. The last stop on this tour will be one of the most well-known haunted saloons on the island, which originally served as a hotel. Overnight accommodations should be in order at the end of our visit, but a night's stay at this place would not be recommended for the faint of heart.

Thus begins our tour of Haunted Put-in-Bay.

PART I

CHECKING IN

1

THE PARK HOTEL

Our first stop on this ghostly tour of Put-in-Bay begins with a check-in at one of the oldest and most haunted hotels on the island: the historic Park Hotel. Located in the heart of the village, this beautifully appointed lodging has accommodated guests for over 140 years, making it one of the oldest continually operating hotels in Ohio.

Our story here begins with the arrival of a man named George F. Schmidt. Schmidt was born in Württemberg, Germany, in 1844 and showed up at Put-in-Bay in late 1870 or early 1871. For the first year or so of his residency, he and his wife, Otilda, operated a small rooming house upon the site. This rooming house was enlarged in 1872 and was soon after called the Deutsches Hotel, which opened the following year.

In 1873, another structure was added just to the east of this new hotel. This building was originally fabricated and set up in Toledo, Ohio. It was immediately dismantled and shipped to South Bass Island, where Schmidt had it reassembled on the lot beside his newly opened lodging. The building was round in shape with a dome and cupola above the main room and measured 150 feet across. At its opening, this establishment was named the Columbia Restaurant, but the public almost immediately started calling it by another, one that simply described the shape of the building. The name stuck, and the following year, Schmidt adopted the moniker. An accurate, if not a very original name, the Round House was a must-see destination for visitors to the island. The public didn't stop with merely changing the name of the bar. They also started to refer to George Schmidt as "Round House Smith." Again, the name stuck.

A description of the Round House from 1874 stated that no gambling was permitted anywhere in the hall, and the facility was elaborately frescoed. It went on to say that attendants were always on hand, in dress coats and white ties, ready to serve refreshments. Dinner was served every evening, as was lager beer.

One afternoon, at the end of one of those early seasons of the Round House's existence, a small group of islanders gathered on the front porch of the bar to have their photograph taken. The following year, even more islanders gathered for a picture. The tradition continued on for many years to follow, with the assembled crowd becoming even greater with each passing year. This end-of-season tradition became known as the Mossback Picture. Incidentally, islanders refer to themselves as Mossbacks, for the fact that they live on a rock.

Things merrily continued on for Round House Smith and his ever-growing family. His business was a smashing success, and he enjoyed a time of prosperity. In 1887, he added on to his hotel by constructing a beautiful four-story tower and adding more rooms, bringing the total guest accommodations up to twenty-five rooms. The character of architecture that he used for this addition was the Victorian Italian villa style. The hotel was almost immediately renamed the Park Hotel, in honor of the beautiful village park it overlooked. The new lobby windows were lavishly adorned with elegant ruby glass scenes depicting local birds. These windows remain to this day.

Though life seemed wonderful for Round House Smith and his family, things took a tragic turn in 1888. Early that fall, Smith developed a low form of a fever, and by the beginning of October, he was mostly confined to his bed. Then, at around six o'clock in the morning on October 3, Smith, in a state of extreme derangement, awoke and walked over to the bureau in his bedroom. He retrieved his revolver and returned to bed. He then pulled the covers up over his head, placed the revolver up to his forehead and pulled the trigger.

The sudden and unexpected suicide of Round House Smith shocked the entire community. His funeral was held immediately, and he was interred in the island's Crown Hill Cemetery in Lot 70C, Row 6.

His wife, Otilda, continued to operate the Park Hotel and Round House for another year, but she ultimately decided that it was time for a change and sold the business. She passed away in 1899 at fifty-eight years of age and joined her late husband on the hill.

The next owner was George M. Baldwin, who reopened the Round House on May 1, 1890, with a grand dance that was free to the public. Baldwin continued in this line until he sold the facility to Sahnke M. Johannsen in

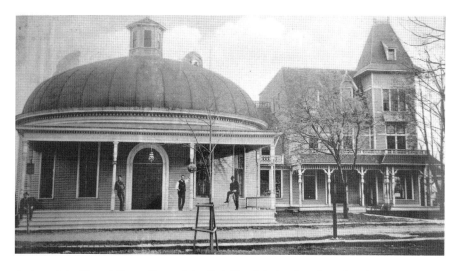

A view of the Round House Bar and the Park Hotel dating from just after the 1887 addition of the four-story tower to the hotel. *Courtesy of the Park Hotel.*

1903. Johannsen only held the Park Hotel and Round House for three years, at which time it was sold to island native Lucas Meyer Jr.

Meyer's father had come from Baden, Germany, during that great influx of Germans to the Lake Erie Islands region. He first landed at Kelleys Island, where he found employment in the great limestone quarries of that island. He then continued on to Put-in-Bay to engage in the grape growing industry. It was on South Bass Island that Lucas Meyer Jr. was born in 1869.

During Meyer's ownership, the Park Hotel boasted accommodations for as many as seventy-five guests and offered visitors a fine dining room, where it was said that the food served exceeded any other to be found on the island.

Lucas Meyer Jr. continued to operate the Park Hotel and Round House longer than any other previous owner, including Round House Smith. On April 1, 1944, Meyer sold the property to Merrill Shaver of Toledo, Ohio. Shaver only stayed in this line for one season and abruptly sold the hotel and bar to William Greunke in October of that year. The following season, the hotel was reopened as Greunke's Park Hotel and stayed thus for many years to follow. Ultimately, the entire complex was sold to the McCann family, who own it still.

Today, the Park Hotel is regarded as one of the finest lodgings on the island. The rooms are intimate and emulate that early era of the hotel's heyday. One thing to remember is that the hotel was not originally equipped with individual bathrooms adjoining the bedrooms. In recent years, men's

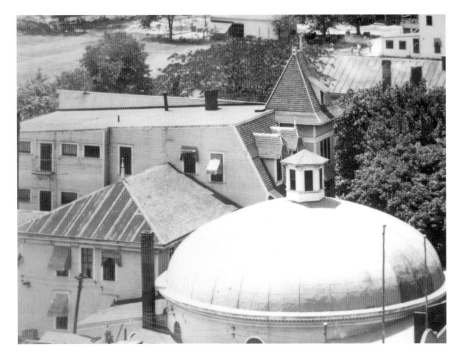

An aerial view of the Round House Bar and Park Hotel Complex. This photo was taken from the top of Perry's Victory and International Peace Memorial. *Courtesy of the Park Hotel.*

and women's locker rooms have been added to each floor. Guests are invited to stay on a nightly basis throughout the week but need to book for two nights over the weekend. Three nights are required for holiday weekend stays. The rates are affordable, and reservations are highly recommended.

In front of the Park Hotel sits a wonderful wraparound porch and a lower patio for outdoor leisure. Here on the patio sits the Crush Bar, which serves cocktails, shots, frozen beverages and beer. On the opposite side of the patio sits the Chicken Patio, where anyone can enjoy a complete dinner consisting of half of a wine-basted chicken hot off the grill, corn on the cob, potato salad and a dinner roll. Located between these two stands are an abundance of picnic tables for dining and relaxation.

Still standing in its original location—immediately to the east of the Chicken Patio—sits the historic Round House Bar. It is here that throngs of visitors still pack in for an afternoon or evening of entertainment and fun. Famously known as the summer home of island singer and songwriter Mike "Mad Dog" Adams, patrons can enjoy a wide variety of music all summer long. The floor is frequently covered in crushed peanut shells, and a

wonderful selection of beer and liquor is available. The walls, as was the case in 1874, are still frescoed, but now with various scenes of South Bass Island spanning its more than two-hundred-year history.

One long-standing tradition at the Round House is the annual lighting of what is known as "The Whiskey Light." In the transom window above the front door sits an orange neon sign. Most neon signs across the island advertise one brand of beer or another. The one at the Round House simply says "Whiskey." The light is usually lit in late April for the first time each season, indicating that the bar is officially open. Another tradition here is the wearing of a red plastic bucket on one's head. This is usually done by first-timers to the bar. Tradition states that you must order a bucket of bottled beer, chilled with ice, and when completed, must then wear the bucket on your head for the rest of the day. Located at the back of the bar is the Bucket Shop, which offers a wide selection of Round House Bar apparel. Located immediately east of the Round House sits another small satellite bar that offers refreshments to visitors in an outdoor setting.

Secreted between the Round House and the Park Hotel sits what once served as the hotel's dining room, the same one that offered food that exceeded any other found on the island during Meyer's ownership. During the Prohibition era, this room also served as a late-night speakeasy. For a number of years that followed, it operated as the only bar that was open throughout the off season. Thus, it was referred to as the Winter Bar. Until recently, it was where the hotel's continental breakfast was served. Today, this room houses the Red Moon Saloon, where extremely high-end and worthwhile cocktails are available. The room is adorned with period wallpaper, reminiscent of the first years of the hotel, and small, Tiffany-style glass candle holders. Incidentally, the tables in this room are the repurposed picnic tables that once graced the barroom of the Round House.

Upon checking into the Park Hotel, visitors may find themselves greeted by Philip Boyles, who is the hotel manager. Philip, who was raised on the island since 1969, spent much of his childhood here playing with the McCann children, whose parents own the facility. Philip's father, Arthur Boyles Sr., worked as the manager for the island's fish hatchery and later became the manager of the South Bass Island State Park. He also owned the Press House Corner Market. For more on that, see the chapter on Joe's Bar later in this book.

Philip Boyles moved away from the island in 1989, but returned in 2011, at which time he took over management of the Park Hotel, where he now resides year round.

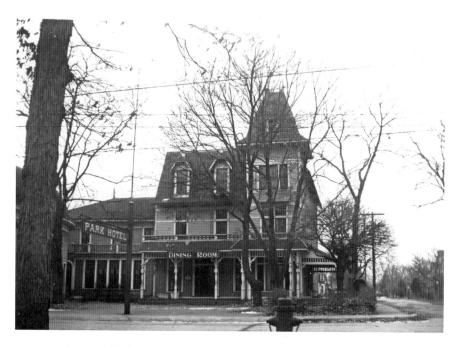

An undated view of the Park Hotel during the off season. *Courtesy of Maggie Beckford.*

The year that Philip moved into the hotel, he almost immediately began to notice the disturbances. The most common of these were the sounds of people walking upstairs, doors opening and closing of their own accord and the sounds of conversations coming from empty rooms. Mind you, all of this happened in the dead of winter while no one else was around, usually around four o'clock in the morning.

Shortly after taking up residency at the Park Hotel, Melinda Myers, one of the McCann children who Philip Boyles grew up with, asked him if a particular door had been acting up. Philip was a little surprised to hear her ask about this. Melinda explained that it used to happen with frequency when she was a child. The door in question is the one that leads from the hotel lobby into the living room of Philip's apartments, located on the first floor. He would frequently find it wide open after having securely closed it earlier. Another disturbance that he noted close to this door was the hallway light periodically tuning on of its own accord.

For the first two years, Philip Boyles occupied the hotel by himself. Eventually, his daughter—who incidentally was not a believer in anything paranormal—moved in with him. It was during this time that

renovations were being made on the upper levels of the hotel. Both were witnesses to the sounds of objects being moved across the upstairs floors well after the carpenters were gone for the evening. When Philip's daughter moved in, she brought a white cat with her. With the arrival of this feline, the door off the lobby curiously stopped opening on its own. Twice, however, Philip and his daughter woke up in the morning to find the cat inexplicably locked out on the back porch. Occasionally, they would even find it locked in a closet.

In 2014, Philip bought a dog, a very friendly female basset hound named Lilly. Shortly after arriving at the hotel, Lilly started to have what could only be described as panic attacks. These would only happen in the living room of Philip Boyles's apartment while the dog was looking up into the corner of the room. On occasion, while families are staying in the hotel, the younger children of these visitors claim to be playing with other children in the lobby. Sometimes, it would seem, the dog would be playing with them also.

Occurrences reportedly relating to children are not strictly limited to the hotel lobby. In one of the upstairs rooms, visitors note the sounds of children laughing or running down the hallway in the middle of the night. In the morning, when they report this to the attendant behind the desk, it is often explained that there were no children staying in the hotel that night. Also reported in this room is the sound of what can only be described as children playing jacks in the next room. If these visitors were to investigate further, they would discover that there is, in fact, no room next to theirs. That door simply leads to a linen closet.

One legend that has circulated about the hotel is the story of a previous owner who hanged himself from the third-floor banister. This is, however, not true. Other stories claim that the suicide occurred in the barn behind the hotel, which now houses seasonal island staff. While it is true that there was a death in this building, it was not a suicide but rather a tragic accident. Some years ago, while the building was still being used as a barn, a man was back there tending to the horses and fell. His body was discovered a short time later.

Another story that is related is one of a woman who fell down the first flight of stairs and into the lobby, where she died from a broken neck. While it is true that a woman was taken off the island in the early 1900s after suffering from such an injury under these circumstances and later died, the name of the hotel in which she fell is not named.

Something that can occasionally be witnessed on all of the floors is the sound of random mysterious knocks upon the bedroom doors.

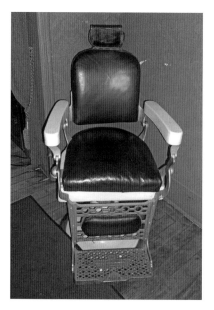

This barber's chair, which once sat at Bill McCann's barbershop, now occupied by Pasquale's, sat for a time in the lobby of the Park Hotel. It has been seen swiveling without any assistance. Today it can be found in the foyer of the Red Moon Saloon. *Photo by the author.*

Philip Boyles did have quite an odd experience in the hotel lobby one day. While working one afternoon, he had heard what he described as the sound of children laughing. When he looked up, he noticed that an old barber's chair, which at that time sat across the room, was slowly turning on its own. This barber's chair now sits in the entry foyer of the Red Moon Saloon next door. Anyone is welcome to try to turn this chair. They can discover for themselves that the pivot is quite stiff and it takes some effort to swivel the seat. Obviously, the wind cannot be blamed for its sudden movement.

Another memorable experience that Philip recalls is how one afternoon at the end of the season, when there were no guests in the hotel, he had been up in room 22 servicing an air-conditioning unit. While deeply concentrating on his work, he heard the door open behind him, and someone ask if he was about done yet. Philip replied that he nearly was. Thinking that it was the boss trying to hurry him up, he finished the work and walked down to the lobby to find it empty. He called the hotel's owner to tell him that he had finished, but the owner had no idea what he was talking about. Furthermore, he hadn't been there all day. The identity of the unidentified man remains a mystery.

A very unique story was also related by John Domer, an island resident since the late 1980s and, among other things, one who is considered by many to be an expert on island lore and ghost stories. Many years ago, John worked at Pasquale's Cafe, which is located directly across the street from the Park Hotel and is also owned by the McCann family. During the winter months, the McCanns employ their staff for other work, such as renovations and regular building maintenance on various properties. One such winter, John had been hired to seal off an old servants' stairway that led from what was being currently used as a washroom to an upstairs hallway. The bottom of this stairwell was now blocked with a washing machine, and the stairs were

no longer in use. The idea was to convert the top entryway to the stairs into a linen closet to offer more storage space for the staff. John began by walling off the old entrance to the stairwell on the first floor. He then completed the task by installing a floor over the top of the stairwell on the second floor.

The following summer, John Domer's niece was working at the hotel. At some point during the season, she came over to Pasquale's to tell him of a most unusual visitor they had just received at the hotel. A woman had come in with claims about how the lobby once looked. She stated that the front desk was once located on the other side of the room, close to where the fireplace sits. John informed his niece that this was, in fact, the case. The niece went on to say that the woman also claimed that a man was trapped somewhere in the building, specifically in a stairwell that was walled off. John clearly explained that only about six people ever knew that this staircase was even there, let alone that it had recently been walled off.

Melinda Myers, when asked about this, said that the woman claimed that the servant was actually trapped in a passage that had been sealed off. Again, this passage was not very well known. In any sense, both can agree that somewhere in that building, someone is stuck and cannot escape.

Should you be looking for a getaway from the troubles of city life and wish to stay at one of Put-in-Bay's most notorious haunted accommodations, a visit to the historic Park Hotel should definitely be at the top of your list.

2
ASHLEY'S ISLAND HOUSE

If it's a quieter and more intimate stay that you're seeking, then Ashley's Island House, located at 557 Catawba Avenue, is certainly the place you'll wish to lay your head—that is, if you don't mind the occasional ghost passing through. This comfortable little bed-and-breakfast, located just one block from downtown, is the island's oldest and largest. Like all historic buildings on the islands, Ashley's Island House has quite a storied past.

The tale of this beautiful little accommodation begins with the arrival of the Doller family in 1852. George Adam Doller and his wife, Christine (née Dorzbach), had come to Ohio from Baden, Germany, with their three children during the great influx of Germans to the Lake Erie Islands region. Unfortunately, Christine Doller died a few years after their arrival in Sandusky and never had the opportunity to enjoy island life. Her widowed husband, with their two sons Chris and Valentine, continued on to South Bass Island in 1859, where Valentine would become one of Put-in-Bay's most prominent citizens. A third son, named John, remained in Sandusky while his father and elder brothers continued on to the islands to lay the foundation for their family's future.

John Stephan Doller, on whom this story is centered, was born in Bammenthal, Baden, Germany, in May 1848. When his mother passed away, John was still quite young. There being no school yet established at Put-in-Bay, it was certain that George Doller wanted his son to receive something of an education, thus John stayed in Sandusky through the early 1860s to attend school. While living in that city, he resided with the

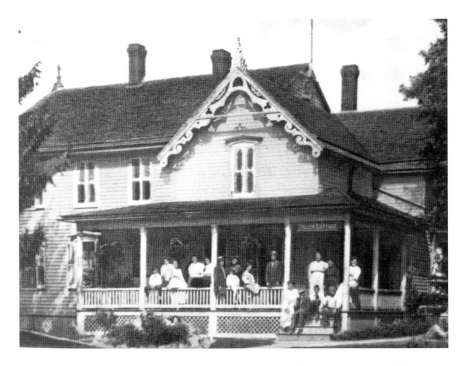

A Doller family gathering on the front porch of the Doller Cottage, circa early 1900s. *Courtesy of the Lake Erie Islands Historical Society Museum.*

Barney family. Within a few years, John joined his father and brothers at Put-in-Bay.

An exact date of construction is unclear, as there are conflicting claims in circulation, but the building of what would for many years after be known as the Doller Cottage is placed somewhere between the late 1860s and mid-1870s. This structure was built as a guesthouse by John's elder brother Valentine. The beautiful little farmhouse carried slight hints of Gothic Revival and was trimmed in ornate gingerbread woodwork. A large wraparound porch was added in later years.

On January 8, 1874, John Doller married Wilhelmina Schelb of Sandusky, whose family operated a boardinghouse in that city. The couple had two daughters, Francis and Celia, and two sons, John Valentine "Vallie" and Howard. By 1880, John and his family were residing on Middle Bass Island with John's father and Wilhelmina's mother. It was here that John worked as the proprietor of a boat house.

A few years later, John and his family moved over to Put-in-Bay and took up residency at the Doller Cottage, where John was engaged as a farmer.

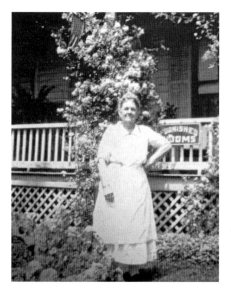

Wilhelmina Schelb-Doller stands in front of the Doller Cottage, circa 1919. *Courtesy of the Lake Erie Islands Historical Society Museum.*

There was a considerable amount of land attached to the property and a barn just behind the house. His wife, meanwhile, operated a lodging house out of the Doller Cottage, which offered comfortable guest accommodations to island visitors. Doller Avenue, which runs beside the house, was named after John and his family.

During the early to mid-1890s, John conducted the boardinghouse on the grounds of the Hotel Victory while it was under construction, which provided housing for the carpenters and laborers engaged on the project. Later in life, he also owned a plumbing shop.

John Stephan Doller died at his home at six o'clock in the morning of April 26, 1921. He had been in failing health for some time, but the death was quite unexpected. His funeral, held two days later, was greatly attended and was described as one of the largest the island had ever seen. The funeral service was held at the residence of Reverend D.A. Cassetta, with the choir from St. Paul's Church providing the music. Interment was at Crown Hill Cemetery.

What was kept out of the newspapers was the fact that the death was actually a suicide. Early that morning, John had gone out to the barn behind the house, and there he fatally cut his own throat. Other reports claim that this actually happened in the woods behind the barn. Besides John Doller, one other death is known to have occurred at this house. On the night of April 10, 1890, a child of Joseph Schelb, John Doller's brother-in-law, died at the Doller Cottage. This story appeared in a Sandusky newspaper, though the article doesn't say which child it was or list the cause of death. All that is known otherwise is that the remains were taken to Sandusky for interment.

The Doller family continued to occupy this house for a number of years following John's death. Wilhelmina Doller passed away in 1938, and the house was willed to her children, who owned it until the late 1940s. After the Doller ownership, it was used as housing for seasonal island employees

of various businesses. It was also, for a time, called the Lake House and was to operate as a bed-and-breakfast, but the venture never quite got off the ground. During this time, the house fell into a considerable state of neglect and disrepair, and its future looked bleak. But then the Bransome family purchased the place in 1992.

There had been some work done to renovate the house, but at this point only three or four of the guest rooms had been refurbished. The house still needed much work. In some parts, there had been raw wiring hanging down from the ceiling, exposed lath and plaster and also a few holes in some sections of the floor. Once the place was habitable, the name was changed to Ashley's Island House and was operated at first by owners Judy and Bob Bransome's daughter Ashley, who stayed on for a time before returning to college to complete her education.

Judy and Bob Bransome took over the operations of the house in 1996. Over the course of the next few years, they continued to make renovations, and soon the remaining thirteen rooms were fully renovated. Each room

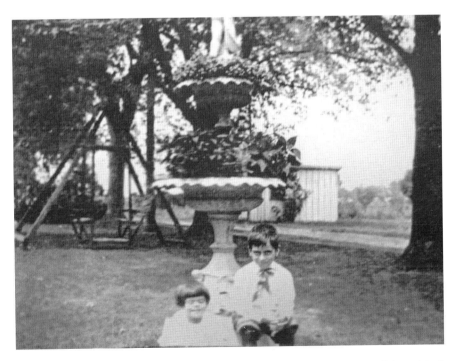

Eunice and Leo Doller, grandchildren of John and Wilhelmina, pose in front of the original fountain that stood on the property of the Doller Cottage, circa 1919. *Courtesy of the Lake Erie Islands Historical Society Museum.*

carries a specific theme and is named to reflect its character. Available to guests are cozy rooms such as the Captain's Room, the English Cottage Room and the Lighthouse Room. Many windows throughout the house still have their original bubble-glass panes.

Today, Ashley's Island House is a very comfortable and beautifully appointed bed-and-breakfast. All rooms have hardwood floors, antique furnishings, queen-sized beds and their own private bathroom. A deluxe continental breakfast is included in every stay. Wireless Internet is also available. Most enjoyable to visitors is the front porch, which is occupied almost every evening by guests.

After the house was finished, the Bransomes invited Eunice Eileen Suter, a daughter of Vallie Doller and granddaughter of John and Wilhelmina, to come for a visit. At first, Eunice flat-out refused to do so. The last time she had been there, the house was in such a sad state and there were rats on the property. It took some convincing, but finally Eunice agreed to a visit. From the moment she arrived and entered the house until she had reached the back rooms, Eunice was in tears. Judy Bransome had thought that she was dissatisfied with the way the house had been remodeled. As it turned out, quite the opposite was the case. Eunice Suter was overjoyed at the appearance of the old family home. In all, Eunice would stay three times with the Bransomes at Ashley's Island House before her passing in 2001 at the sublime age of eighty-seven years old. Other members of this family would also visit, and still do on occasion.

In regards to the haunting aspect of the house, Judy Bransome relates that some years ago, a young Serbian woman had come to work at Ashley's Island House. She had asked Judy if the house was haunted, to which Judy replied that she had never seen a ghost. On the first day that the young woman was to begin work, she came into the formal front parlor of the home, at which point all of the hairs on her arms stood up. The girl began to slowly back out of the room. When asked what was wrong, the girl informed Judy that she could not enter that room again for the fact that there were far too many spirits and ghosts in that room. She explained that she could feel them all around that front parlor. Personally, Judy Bransome has never had any experiences in that room, nor has anyone else for that matter.

The first year that the Bransomes were at Ashley's Island House, Judy was doing some spring cleaning in the upstairs rooms that April, and the hour was growing late. She was finishing some vacuuming in room 9 at around one or two o'clock in the morning when suddenly all of the pictures started falling off of the walls. One after another, they dropped of their own accord.

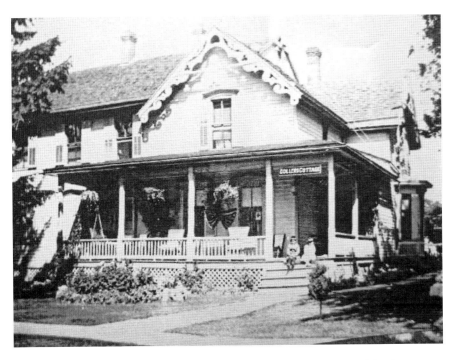

Leo and Eunice taking a break on the front porch of their grandparent's lodging house, circa 1919. *Courtesy of the Lake Erie Islands Historical Society Museum.*

Finally, Judy turned off the vacuum and left. She had gotten the message and vowed never to vacuum up there again at such a late hour. She has never had another episode like that up in that room since.

The most common disturbances occur in room 2, also known as the Captain's Room. This room is decorated with a nautical theme, and the walls are adorned with pictures of the brig *Niagara* and navigational charts. One incident that was related was that of an FBI agent and his wife who had been staying in this room. The agent had been out in the hall outside of the room talking with Judy when his wife suddenly came out and asked him why he didn't answer her when she had addressed him a few minutes ago in the bedroom. The agent explained that he wasn't in the bedroom and had been out in the hall the entire time. His wife was in disbelief. She swore that while she was cleaning herself up in the adjoining bathroom just moments earlier, he had been sitting at the end of the bed. When she asked him a question, he didn't reply. She turned back toward the bedroom and, looking through the doorway, discovered the room to be empty. This was the first incident that the Bransomes were made aware of in room 2. Since then, quite a few other

An unknown man appears here in room 2, also known as the Captain's Room. *Photo by the author.*

visitors have made similar claims. One woman took a picture of the room and almost immediately noticed the figure of a man standing in the back of the room. From then on, the woman was quite convinced that the place was haunted. It is a common belief that the man that is frequently seen in room 2 may very well be John Stephan Doller, who ended his life most tragically that April morning in 1921. Until he decides to start replying when people call out to him, mistaking him for their husbands, there will be no way to be certain.

Bob and Judy Bransome, along with their manager, Kelly, and their annual staff, will be very happy to receive you at this lovely island bed-and-breakfast, as may a few other household members that are hidden just from view.

PART II

SIGHTSEEING

3

SOUTH BASS ISLAND LIGHTHOUSE

Now that we've secured our accommodations and have checked in, it's time to take in a little sightseeing. One of the first destinations should be a stop at the old South Bass Island Lighthouse. Leaving town, we head west on Langram Road, pass the airport and press on toward the Lime Kiln Dock, where the Miller Ferry departs regularly for Catawba Island. Continue past the Miller Ferry, and Langram Road ends at Parker's Point and the lighthouse.

The South Bass Island Lighthouse, also sometimes referred to in the past as the Parker's Point Light or the South Point Light, is a unique example of a combination navigational aid and dwelling. The tower, which rises sixty feet above the nearby cliffs, is actually attached to the lighthouse keeper's residence. The Queen Anne–style dwelling is of brick and sandstone construction and features spacious living quarters with lavish gilded moldings throughout the home.

Plans for this lighthouse were first conceived in 1893, when it was realized that there was a need for a navigational aid along Lake Erie's South Passage between the lighthouse on Green Island and the one on the Marblehead Peninsula. The next year, the U.S. Lighthouse Board gave the go-ahead for the project but limited the expenses to $8,600. Lieutenant Colonel Jared A. Smith was selected as the architect. Alfred and Mary Parker sold two acres of land on the point for $1,000 to the U.S. Government for the use of the future lighthouse in May 1895, and two years later, the project was complete. The light was first illuminated on the night of July 10, 1897. A reliable

sentinel, it operated nightly between early March and late December, when the shipping season ended and the lake would be covered in ice.

All in all, at the time of its construction, this lighthouse was by far the costliest on Lake Erie. The Fresnel lens alone cost $1,500 and was imported from France. It held a revolving fourth-order light that alternated between red and white flashes. The white flash was 200,000 candlepower, while the red one was at 45,000. The shimmering light was visible at a distance of fifteen miles. Originally, the beacon was lit with an oil lamp, but it was eventually converted over to electricity. The old oil house, built the same year as the lighthouse, still stands on the grounds, as do a barn and chicken coop that were erected in 1899.

Old lighthouses typically conjure up images of a remote life and a weather-beaten sea captain attending to his nightly duties. You can almost see him dressed in his blue captain's coat, wearing a turtleneck sweater and holding a lantern in his right hand as he ascends the spiral staircase to the top of his tower. He has a gray beard and wispy white hair, and his eyes tell you stories of the worst storms ever witnessed on the lakes. The first such man to tend the South Bass Island Lighthouse was Harry H. Riley, who began his service

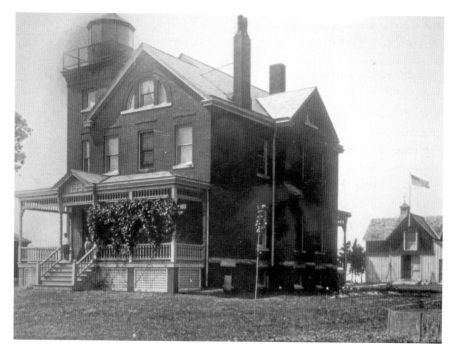

The South Bass Island Lighthouse in its earliest years of operation. *Courtesy of the Lake Erie Islands Historical Society Museum.*

at the light on June 23, 1897, some twelve days before the lamp would be ignited for the first time.

Harry Riley was born in New York and found himself drawn to a life at sea. He served for three years in the U.S. Navy, after which time he was employed as the helmsman of the lighthouse tender U.S. *Haze*, a vessel that carried supplies to various lighthouses across the Great Lakes. After three years on the wheel, he took over as second mate. Shortly before arriving on South Bass Island, Harry Riley married and resided with his new bride in Detroit, Michigan. At the age of forty-one, he accepted the position of keeper and was to be paid an annual salary of $560.

On August 9, 1898, a little over a year after beginning his term as keeper, Harry Riley hired on an elderly African American man named Sam Anderson, who had also worked at the Hotel Victory, to be his assistant light keeper. The two became close friends almost at once. Anderson had a curious hobby of collecting a wide variety of snakes. He kept these in the basement of the lighthouse, where his living quarters were located.

Later that same month, there were a few cases of smallpox reported among some of the staff members at the Hotel Victory, and a quarantine of that end of the island was put in place. Sam had grown quite paranoid and was scared out of his mind at the very thought of contracting the disease. As it turned out, all of these cases were quite mild, and those afflicted recovered shortly after.

Sam, however, tried to isolate himself by hiding in the basement with his snakes. Eventually, his fears began to get the better of him and to deal with this, he took heavily to drinking, which only made matters worse. From here, specific details are a little sketchy. One report states that Anderson attempted to escape by trying to sneak past the quarantine guards posted at that end of the island. He was caught, however, and returned to the lighthouse but refused to enter. He spent the entire night outside howling madly, and his body was discovered the following morning on the rocks below the cliff, where he'd hurled himself during the night. Another story claims that after taking all that he could of the fears of possibly contracting smallpox, he had walked down to a nearby dock, yelled "God save them all" and jumped into the lake. A further thought was that he might have actually fallen off of the cliff rather than having jumped. What is certain is that Sam Anderson was alive, but very disturbed, on the night of August 31, 1898, and the next morning he was dead.

While two of these stories claim that his death was ruled a suicide, all three agree that Sam Anderson's body was recovered from the lake the

following morning. Interestingly, all of them also claim that his burial location is unknown. This is not entirely true. Anderson's wages for the time he had worked at the lighthouse, which came out to $17.25, were claimed by the local justice of the peace and county coroner. The funds were then used to cover the cost of Anderson's burial expenses. At that time, the only cemetery on the island that was in use was Crown Hill Cemetery, at the west end of the island. One little interesting tidbit about that cemetery is that it does, in fact, have a potter's field located within its perimeters. A common occurrence each spring would be a body washing up on shore after the ice on the lake would begin to break up and melt. These poor souls that were discovered on the rocks and beaches would be brought over to Crown Hill for interment, but no marker would be placed above them. The location of these unknown burials lies directly beneath the little grass-covered drives that cut though the cemetery. Sam Anderson is most likely taking his repose among these forgotten dead of South Bass Island.

In an interesting turn of events, lighthouse keeper Harry H. Riley was discovered the day after Sam Anderson's body was recovered from the lake wandering around Sandusky, boasting about a race horse that he owned. In fact, he never owned such a horse. He was picked up by the police and charged as an insane person. It is widely believed that the shock of Sam's sudden and violent death had pushed Riley over the edge. Within a few days, Harry Riley was sent to the Toledo Asylum for the Insane. His wife and a man named Otto Richey were placed in charge of the lighthouse until Riley's condition could be properly evaluated. The diagnosis was not good. It was determined that he was beyond treatment. Riley was officially relieved of his duties in late February 1899, and a month later, he was dead.

Again, as is the case with Sam Anderson, all references to Harry Riley claim that the location of his burial is also not known. Most likely, he would have been buried in the old cemetery at the Toledo Asylum for the Insane. This burial ground was in use between 1888 and 1922, at which time it had reached its capacity of nearly one thousand interments, and a new one was opened three-tenths of a mile to the southwest.

A month after her husband's death, Mrs. Riley left South Bass Island, and the lighthouse had a new keeper named Enoch W. Scribner, about whom very little is known. He would remain at this post for a little over a year. The next keeper was a man named Mason, who stayed on until 1908.

The longest-serving keeper of the light was Charles B. Duggan, who took the position in 1908. Duggan was born on March 14, 1866, at Sackets Harbor, New York, and had five years of previous experience as keeper at

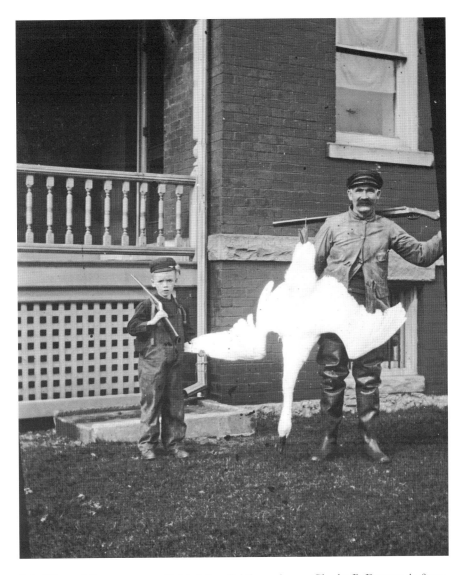

Lyle "Cotton" Duggan poses with his father, lighthouse keeper Charles B. Duggan, in front of the South Bass Island Lighthouse with a bird they recently hunted, circa 1910. Fifteen years later, Cotton Duggan would take over as the lighthouse keeper following the passing of his father in 1925. *Courtesy of Maggie Beckford.*

the lighthouse on West Sister Island. As a young man in Sackets Harbor, he learned the carpenter's trade. At thirty-two years of age, he began work at the lifesaving station in Buffalo, New York, and five years later took the job on West Sister Island. Aside from tending to the light, Charles Duggan was

also a farmer and had twenty acres of grape vineyards and peach orchards. For the next seventeen years, he resided at the lighthouse with his wife, Bertha, and three sons, Arthur, Archie and Lyle. His mother-in-law, Sarah Graham, also resided here for a time.

Unfortunately, Charles Duggan died on April 29, 1925. Many stories claim that he fell thirty feet from a cliff on the grounds of the lighthouse. This, according a descendant, is not the case. He died, in fact, from a heart attack and not from some mysterious fall. This story has been overly sensationalized for too long, so that should be the end of that. After his burial at South Bass Island's Maple Leaf Cemetery, his son Lyle, better known as Cotton Duggan, temporarily took over as the keeper of the light for the rest of the 1925 season.

The year 1926 saw the arrival of Captain William L. Gordon. Captain Gordon, a World War I veteran, was given charge of the lighthouses on Green and Ballast Islands as well as all of the buoys in the area.

Canadian-born Frank LaRose was keeper from 1939 to 1941 and occupied the lighthouse with his wife, Effie. Like Charles Duggan, Frank LaRose, who died in 1957, is also buried in Maple Leaf Cemetery on South Bass Island.

Serving during the majority of the World War II era, Robert Jones may also have been employed previously as the keeper at the Marblehead Lighthouse. Kenneth Nester followed Jones and served as keeper from 1944 until 1947.

The final keeper of the South Bass Island Lighthouse was Paul F. Prochnow. Prochnow was born in Landsberg, Germany, on December 19, 1892. He came to the United States from the port of Bremen aboard the SS *Youck* and landed in New York City on July 25, 1923. Joining him on the voyage was his wife, Anna; eleven-year-old daughter, Emma; and ten-month-old son, William. Immediately after arrival, the Prochnows settled in Sandusky, where Anna's father, Friedrich Wittig, resided. Paul first found work as a fisherman, but by late 1930, he was working as the first assistant keeper at the lighthouse at Cedar Point, where he continued to work for seventeen years, at which time he took the position at the South Bass Island Lighthouse.

Aside from tending to the light, Paul Prochnow was also placed in charge of the navigational beacons atop Perry's Victory and International Peace Memorial. During his term as keeper, Prochnow received the Distinguished Service Award from the U.S. Coast Guard. Upon his retirement on October 31, 1962, the South Bass Island Light was replaced by a single steel tower with an automated beacon at the top. The old lighthouse has been dark ever since.

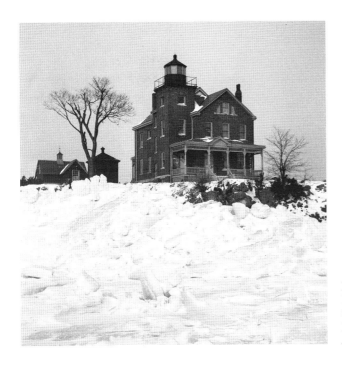

Ice piled high on Lake Erie around the South Bass Island Lighthouse. *Courtesy of Maggie Beckford.*

Paul Prochnow enjoyed a somewhat short retirement and passed away less than seven years later at Providence Hospital in Sandusky. He was buried at Oakland Cemetery in that city.

In 1967, the U.S. Government transferred ownership of the lighthouse, its outbuildings and two acres of land to the Ohio State University, which originally used it as staff housing for Stone Lab on Gibraltar Island, but now uses the structures for educational purposes. It is open for tours on Mondays and Tuesdays during the summer months, and the house is being restored to its original glory.

The South Bass Island Lighthouse was listed in the National Register of Historic Places on April 5, 1990, as ID number 90000473. The Fresnel lens that safely guided so many ships through the South Passage for sixty-five years is now on display at the Lake Erie Islands Historical Society Museum.

Paranormal disturbances have been reported at this site for many years, primarily in the form of a ghostly apparition of a man walking the grounds and the lighthouse tower. Could it be Sam Anderson still trying to distance himself from the quarantine zone or perhaps some past light keeper returned to continue his watch over the South Passage? We may never know. Most haunted in the lighthouse is the basement where Sam Anderson once resided with his snakes. Few people dare to venture into that part of the house.

4

THE COUNTRY HOUSE

One of the most popular things to do at Put-in-Bay is souvenir shopping. Returning to the village, we find the Country House, located at 246 Delaware Avenue, right in the heart of town. This Victorian-era structure was originally built as the Gill House in April 1874 by Fred and Celia Gill.

Fred Gill had been born in Kentucky in 1850 to German immigrants. Prior to opening his hotel, he was employed by Valentine Doller as the manager of the Atlantic Billiard Hall, where many island visitors came to unwind in a fun and friendly atmosphere.

The site on which the Gills chose to build their hotel was a part of the space that had been the eastern yard of the first Put-in-Bay House. That hotel burned down four years later. Fortunately, the Gill House was spared due to a strong east wind. The same could not be said for some of the buildings that sat to the west across the street on Catawba Avenue. This island accommodation featured fourteen guest bedrooms upstairs. It boasted a grand lobby up front and a restaurant in back of the building. The inside was adorned in beautiful German fretwork. It was Italianate by design and had an ornately carved grand staircase, which led from the lobby to the rooms above.

Sadly, just two months after the grand opening of the Gill House, Fred and Celia's two-year-old daughter, Gertrude, passed away in the hotel. Her death occurred on June 7, 1874. She was buried in Lot 21 A at Crown Hill Cemetery.

The Gills continued to operate the Gill House until the late 1880s, at which time they relocated to Grand Rapids, Michigan. When Celia passed

away, she was buried in that state, but when Fred Gill died in 1930, he chose to be buried at Put-in-Bay and now takes his repose beside his daughter.

By 1890, the hotel was being operated as the Hotel Oelschlager by Engelbert and Amelia Oelschlager. Engelbert A. Oelschlager was born on August 3, 1853, in Švedlár, Gelnica, Slovakia, and immigrated to the United States in 1873. He was married on June 19, 1879, to nineteen-year-old Sandusky native Amelia Baer, daughter of German immigrants George and Mary Baer. Three sons would be born to this union, two of which, Adolph and Norbert, passed away in infancy shortly before the Oelschlagers took possession of the Gill House. Engelbert also owned and operated a grocery that was located in an old wooden building next door.

The Hotel Oelschlager saw its heyday between the years 1890 and 1911. It was noted as being nicely located, opposite the public park near both of the boat landings. The hotel bragged that its service could not be excelled, and its rates were quite reasonable.

Shortly before Engelbert Oelschlager's death, which occurred on Christmas Eve 1913, his surviving son, Carl, rebuilt the aged and outdated grocery building next door. When it was completed, this new grocery store was the only brick structure on Delaware Avenue. Today, that building

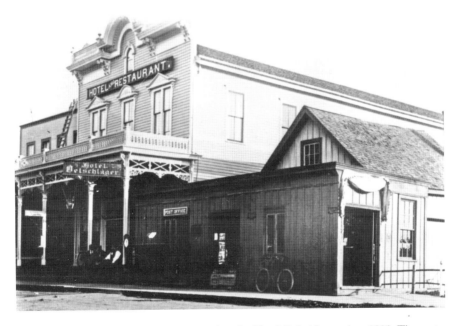

The Country House, back when it operated as the Hotel Oelschlager, circa 1900. The post office (*right*) would be replaced in 1913 by the brick building that now houses the Frost Bar. *Courtesy of Maggie Beckford.*

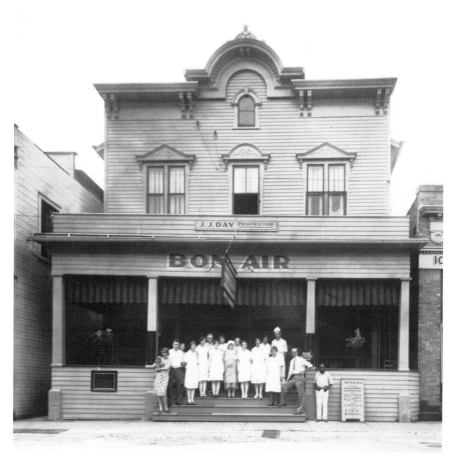

Members of the staff pose in front of the Bon Air, circa 1925. *Courtesy of the Lake Erie Islands Historical Society Museum.*

operates as the Frosty Bar at 252 Delaware Avenue. This island treasure is widely known for its original floral tin ceilings but more so for the pizza it serves, which has become an island favorite.

For a time, the Hotel Oelschlager was known as the Central Hotel, but little, if anything, is known about that era or the owners, except that it bore this name very briefly. By 1925, it was operating as the Bon Air. The restaurant still operated out of the back of the building.

In 1938, the hotel became the Smith House, with Walter Smith as the proprietor. Walter Sylvester Smith was born on January 3, 1902, on South Bass Island to Ben and Mary Elizabeth Miller Smith. On December 19, 1935, he was married in Toledo to Lillian Eva Seidelbauer. The two took

over the operations of the hotel three years later. Rather than residing in the hotel as many past owners had, the Smiths lived in a house on Toledo Avenue. Walter also operated a taxi company on the island.

Walter and Lillian remained happily married until her untimely passing, after which he was married to Dorothy Pauline Lenn of Cleveland.

The hotel boasted that it was clean, quiet, comfortable and affordable. It continued to operate for many years and had become a favorite destination for many visitors. During the winter months, the Smiths left the island and resided in Largo, Pinellas County, Florida. It was here that Walter's death occurred on January 12, 1966. His remains were brought back to Put-in-Bay for burial beside his parents at Crown Hill Cemetery. Dorothy continued to operate the hotel for some time before her passing in Florida in 1973.

Today, this building operates as the Country House, Put-in-Bay's largest and most interesting gift store. It specializes in Put-in-Bay souvenirs such as postcards, mugs, key chains and picture frames. It also offers artwork and books from local artists and authors, as well as nautical-themed furniture and housewares. The main floor of the shop, which once served as the hotel lobby, still contains the original German fretwork and the ornately carved staircase that once led visitors to their accommodations upstairs.

Island lore claims this building to actually be, by far, one of the most haunted on the island. Aside from typical ghostly experiences like sounds and footsteps, an actual manifestation is occasionally witnessed. This appears in the form of a young man, dressed in a uniform, sitting near the bottom of the stairs. It is uncertain as to who this person might be, a past guest of the hotel, perhaps, but someone, besides the staff and shoppers, is definitely hanging around at the Country House.

5

THE PUT-IN-BAY WINERY
AT THE DOLLER ESTATE

Perhaps at this point we may wish to enjoy an afternoon refreshment. Beer and liquor can be found in any establishment, but if we're talking about Put-in-Bay heritage, we're talking about wine. There are two wineries on the island. One is Heineman's Winery out on Catawba Avenue headed toward the State Park and across the street from Perry's Cave Family Fun Center. Not only is Heineman's the oldest family-owned and operated winery in Ohio, but it is also the home of the Crystal Cave, which is the largest known geode in the world. For a small fee, visitors can take a tour of the winemaking facility and stroll through the huge celestite cave forty feet below ground.

The other winery on the island is the Put-in-Bay Winery at the Doller Estate, located at 392 Bayview Avenue, just beyond town heading out toward Peach Point. Here, visitors can enjoy a glass of wine out in the wine garden or on the beautiful front porch of the Valentine Doller House, which offers magnificent views of Put-in-Bay Harbor. Also available are tours of the historic island home that houses this establishment and the Island Life Museum, which features the last remaining icehouse on the island.

Looking back on the chapter on Ashley's Island House, we'll recall that the Doller family first came to the island in 1859, that being George Adam Doller and his sons Chris and Valentine. It should be noted here that Valentine Doller was born in Bammenthal, Baden, Germany, on November 28, 1834. Before setting out for South Bass Island, Valentine married Catherine Hass, a daughter of Phillip and Charlotte Hass, who

was born in Württemberg, Germany, on February 3, 1839. The two were married in Sandusky on April 16, 1859, and immediately after departed for the island. To this union would be born six children, all daughters: Fanny, Emma, Lillie, Lottie, Daisy and Olga. They also raised their two nephews William and Edward Hass.

Valentine Doller had initially come to Put-in-Bay to work for Joseph De Rivera St. Jurjo to help him in further developing the island, initially by operating the lumber company. Upon his arrival, he was promised a home with a carriage house and five acres of land. The house that he received was originally built sometime during the mid-1850s. According to Daniel Vroman, the son of longtime island resident and historian Philip Vroman, the house had been built a few years before Valentine Doller had arrived on the island and had been placed there to house the people who operated the old steam sawmill that originally stood on the grounds of the estate. Daniel Vroman recalled that the first funeral he ever attended was held there. The family that was in charge of the sawmill had lost one of their children in infancy, and the funeral was held in that house. The child was then buried between two maple trees over on Gibraltar Island.

That original house was remodeled between 1868 and 1870. Fifteen years later, a large addition was added to the west side of the house. This second phase was constructed entirely out of brick, was Italianate by design and featured a large octagonal tower with a widow's walk on top.

As the years progressed, Valentine Doller became quite actively involved with the community. He served as mayor, secretary of the Put-in-Bay Wine Company, justice of the peace and postmaster and was a member of the board of education and Put-in-Bay village council. He also became quite a successful tourist industry entrepreneur. He introduced telegraph service to the island, started the ice industry there and was the owner and operator of the Second Put-in-Bay House, which replaced the first one when it burned down in 1878.

During the early 1880s, Valentine Doller purchased the remaining properties and island holdings of Joseph De Rivera St. Jurjo when that benevolent island founder was bankrupt after his son ruined his company in New York. Valentine Doller also operated a saloon, dry goods store and post office on the corner of Bayview and Catawba Avenues. According to Daniel Vroman, this building began its life as a lumber warehouse for the steam sawmill company and, like the original house, was remodeled by Valentine Doller. For many years, it was known as the Doller Store. Today, this building is occupied by Mossbacks Restaurant and the Fishbowl. He

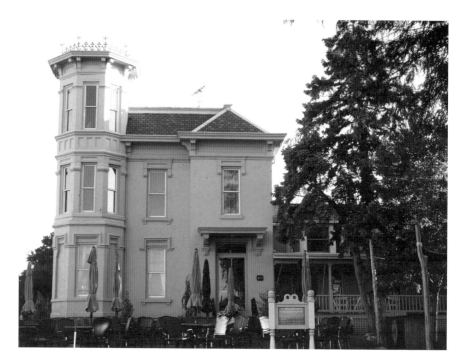

The Valentine Doller House was built in two sections. The original part on the right-hand side was built around 1855, while the Italianate section on the left was added between 1883 and 1885. *Photo by the author.*

also owned a commercial dock and boat livery. For more information, see the chapter on Topsy Turvey's.

Of all of his children, only his eldest daughter, Fanny, married. Her husband was Frank F. Miller. They had only one child, a son named Roderick who did marry but had no children of his own. When Fanny Doller married Frank Miller, Valentine built her and her husband a house on the grounds of his estate so that they would remain close.

Legend states that Valentine Doller and his wife forbade their remaining daughters from marrying. It was further said that the women were quite eccentric and reclusive. However, according to some islanders who knew them fairly well, this was not the case. The women were well educated and well traveled. Had they married, their husbands would have had control over their lives and fortunes. Also, they weren't that reclusive, either. One islander in particular recalls seeing one of the daughters regularly sitting out on the front porch sipping on something that he was certain wasn't lemonade. It is also claimed that the Doller daughters burned all of their family photos,

letters and diaries before they died. This also is not entirely true. There is a grand portrait of Valentine Doller to be found at the Lake Erie Islands Historical Society Museum.

After the death of Valentine and Catherine's last remaining daughter, Olga Beatrix Doller, on June 16, 1974, the house and estate were deeded to her caretakers, John and Elizabeth Nissen. A magnificent burial vault containing the entire Doller family is located in Crown Hill Cemetery.

In regards to the haunting of the Doller house, it is believed that the spirit of at least one of the Dollers, if not more, still wanders the house. Seven members of this family died here, starting with Valentine on May 1, 1901. Of course there's also the infant child of the previous sawmill manager who died and was buried out of the old part of the house. In all, eight deaths have occurred here. Someone was bound to see something.

One such person was Terry Heidenreich. Terry's father and stepmother purchased the old Doller estate in 1978. It was at this time that he started to come up for visits and would stay for a couple of days at a time during the week. In 1980, he purchased the Skyway Restaurant and Bar, located off Langram Road out by the airport. For more on that, see the chapter on the Skyway Restaurant and Bar. Terry owned the Skyway until 1998, at which time he moved to Florida.

During his time at Put-in-Bay, he resided at his father's house from 1978 until 1983 and used to sleep in the older part of the home. It was while residing here that Terry Heidenreich experienced a most alarming disturbance. When he woke in the middle of the night, perhaps to use the restroom, or even when he would wake up in the morning, an unseen force would be holding him down in bed. He clearly states that it felt like a person holding him down. He could feel a body over him and was unable to rise. This would happen for about three or four minutes at a time. Finally, he would be released and clamber out of bed. Sometimes he wrote this off by thinking he might have had too much to drink the night before. Regardless, it was quite some time before he decided to bring it up to anyone.

Finally, one afternoon while the family was assembled at the house for dinner, he decided to mention what was going on in his bedroom. At this, his brother-in-law said that it was a strange coincidence because the exact same thing had been happening to him. He had held off on saying anything about it because he was worried that someone might think he was nuts.

It should be pointed out that the same event was happening to these two men at the same time. Incidentally, both men were staying in the old section of the house. All in all, there are three bedrooms in that section. Terry

Heidenreich and his brother-in-law occupied the two bedrooms that are in the front of the house.

The only other thing that Terry recalled from his time in the Doller House was that his father, who lived in the newer section of the house, occasionally had the feeling of someone following him about the place. Should he turn to look he'd find himself quite alone.

The house became the Put-in-Bay Winery at the Doller Estate in May 2009 and has been offering a pleasurable experience by serving a grand variety of wines to visitors ever since. The year 2015 saw the return of Terry Heidenreich to South Bass Island. Until recently, he had been taking care of his mother. After she passed away, he was invited to come back by his friend Robby Morrow, who manages the winery. Here, he could work in his father's old house, sell wine, give tours and even occupy his former bedroom. Since his return, Terry Heidenreich has not had any experiences like the ones he and his brother-in-law shared back when he lived there in the late '70s and '80s. Perhaps a familiar face in the house has pacified whoever it is that walks those rooms.

6

THE CREW'S NEST

Continuing on toward Peach Point, we next come to the Crew's Nest at 480 Bayview Avenue. This private boating club is family friendly and offers its members access to a bathhouse, an Olympic swimming pool, a lap pool, a junior Olympic swimming pool and an adults-only lounging pool. It also offers tennis, basketball and volleyball courts in addition to a fitness center. The docks, located across Bayview, provide shelter in one of the most protected parts of the harbor and come equipped with electrical and water hookups. Also located across the street are the clubhouse offices and a gift shop.

As for the clubhouse itself, it proudly boasts an upstairs dining room that provides a spectacular view of the harbor and a memorable dining experience. Here, members can enjoy a wide variety of beef cuts and pastas, as well as fresh seafood, including Lake Erie walleye and perch, while relaxing in a comfortable and elegant atmosphere. The clubhouse lounge, which is located on the first floor, provides an air-conditioned event space, wicker rocking chairs on the front porch and a gazebo and patio with an equally splendid view of the bay. Every weekend night in July, live entertainment is provided at the patio bar

The building, which is now occupied by the clubhouse, began life as the Eagle Cottage Hotel in 1875. It was constructed in the Italianate style and operated by the families of Captain Frederick J. Magle and his son-in-law Andrew Alexander Robertson Bruce, who was married to Fred Magle's daughter Elizabeth. Both men also operated the steam-powered icebreaker *American Eagle*.

Frederick J. Magle was born in Sandusky on January 31, 1838, and came to the island in 1850. It was on South Bass Island that he married Nancy

E. Sullivan on June 6, 1858. Frederick and Nancy would have five children, and like Valentine and Catherine Doller, all of their children would be daughters. Katie, Elizabeth, Caroline, Mary and Jessie Magle would spend their formative teenage years helping out with the day-to-day operations of the Eagle Cottage Hotel. Frederick J. Magle died in 1910, followed by his wife in 1925. After the death of the Magles, Andrew and Elizabeth Bruce continued to operate the hotel.

Aside from offering upstairs guest rooms to seasonal visitors, the Eagle Cottage Hotel also boasted a fine barroom, which was located on the first floor, where the lounge for the Crew's Nest can be found today. One person who is known to have tended bar here was John Brown Jr., son of the heroic abolitionist of Harpers Ferry fame. Brown served the Union army as a cavalryman during the Civil War but was forced to resign from the army in May 1862 due to a severe case of rheumatoid arthritis. At this time, he moved to South Bass Island, where he was engaged as a farmer and land surveyor. Tending the bar at the Eagle Cottage Hotel simply gave him something else to do with his free time as well as a chance to be sociable and get to know some of the island's visitors. This bar would be removed in later years and now sits at a saloon along Delaware Avenue. For more on that, see the chapter on T&J's Smokehouse.

Walter and Mary Laskowski purchased the Eagle Cottage Hotel in the spring of 1946. It was at this time that the place was renamed the Friendly Inn, a rooming house that offered accommodations to island visitors year-round. Even though there was no central heating in the building, ice fishermen would come and stay in the rooms, which during the winter months were heated by fuel oil space heaters. Mary Laskowski also provided meals for all of their guests.

On August 23, 1948, there was a tragic accident that involved one of the guests. Charles Pasek, a maintenance man for the Ohio Crankshaft Company in Cleveland, had been staying at the Friendly Inn and decided to go fishing early that Monday morning with Walter Laskowski and a friend in Laskowski's outboard motorboat. It was while fishing somewhere off of Middle Bass Island that the tragedy occurred. Pasek had been fishing from the stern of the vessel while Laskowski and the other man were fishing together in the bow. At one point, they heard a splash but thought nothing of it. A few minutes later, they noticed that Pasek was no longer with them. They immediately notified the coast guard, which dragged that area of the lake for the next few days, after which time they called off the search. The body of Charles Pasek was finally recovered that Saturday when it washed

ashore at North Bass Island. Ottawa County coroner Dr. George A. Poe ruled the cause of death as accidental drowning.

The Friendly Inn was ultimately purchased in 1868 by Allan H. Neff and business partners Marvin Booker and Ken Turvey. At this point, the Friendly Inn had been closed for some time and was in something of a state of disrepair. The renovations began almost immediately, and a membership program began in 1970. The Crew's Nest finally opened to its members in July 1972, with the original swimming pool and bathhouse installed the following year. The year 1974 saw the addition of the upstairs dining room. Also available to members were the newly renovated docks across from the clubhouse, which until that time had been operated by the Slatmeyer family.

In the early 1980s, the property was sold to Bernard "Mack" McCann, whose daughter, Melinda Myers, now sees to the day-to-day operations of the club. Beginning in 1991, many renovations were made to the property, including the addition of the fitness center. The following year, a new bathhouse was added to the property, and in 1994, a spacious pavilion was placed in the yard behind the pool. This was built to accommodate large groups for wedding receptions, family reunions, picnics and large parties. The year 1995 saw the addition of a 1,156-square-foot kitchen to the back of the original building. In honor of Mary Laskowski, who provided meals to guests at the Friendly Inn, the new kitchen and catering facility was named Mary's Kitchen. At this time, the old kitchen in the original part of the building was cleared to make way for a dance floor, stage, sitting area and additional dining. The former dining room of the Friendly Inn, which had first started off as the barroom of the Eagle Cottage Hotel, now serves as the Crew's Nest lounge, the tables in which originally came from the former upstairs guest bedrooms. Walter and Mary Laskowski's upstairs bedroom was converted into an office and computer room. Additionally, the windows of the dining room, which offer a superb view of the harbor, were salvaged from the ruins of the Colonial, which burned to the ground on Memorial Day weekend in 1988.

Some claims regarding the haunting of the Crew's Nest state that the ghosts who walk that building are in fact those of the people who are buried across the street from the former hotel. A little-known fact is that the front yard of the Dodge House, which lies just to the west across Victory Avenue, once served as the first island cemetery. For a time, this claim was in question, as a couple other sites were suggested as the location of this early burial ground. However, an account of this first cemetery was discovered in a handwritten memoir by islander Daniel Vroman. He clearly states in this

The Crew's Nest offers it guests fantastic views of Put-in-Bay harbor. *Courtesy of Maggie Beckford.*

account that the front yard of Captain Elliott Dodge's home was their early place of burial. Daniel Vroman also claimed that many of his school mates lie buried there. Some were moved to the hill cemetery overlooking Stone's Cove, which is today's Crown Hill Cemetery. He concludes by saying that the old cemetery is now a thing of the past. His father, Philip Vroman, noted in an 1892 newspaper article that this site was also where many enlisted sailors and marines from the Battle of Lake Erie were also interred. Quite a few British and Americans died of their injuries after that famous battle and were interred at this site. Knowing the grounds to have previously received burials, the early island residents chose it as their cemetery. Why the ghosts of those people buried there would choose to haunt the Crew's Nest and not the Dodge House is unknown.

Someone who does know a thing or two about the experiences in the Crew's Nest is Melinda Myers, Mack McCann's daughter. The first story related by Melinda is possibly the most common one that is experienced in the building. One time, during the off season while the place was closed for the year, she and the manager had gone into the building to retrieve a vacuum cleaner. Shortly after entering the premises, they both heard the distinct sounds of footsteps coming from the room above them. The place

being closed, there should have been nobody else in there. Melinda went up to investigate the source of the footsteps but returned quickly, saying that the place was empty. At this, the manager began to grow a little unsettled. They grabbed the vacuum cleaner and left the building.

A similar incident occurred some time later when Melinda was in the front room of the Crew's Nest with her sister. The two women were at this time busy putting together Easter baskets, when again, the mysterious footsteps could be heard in the room above them. Again, the clubhouse was not yet opened for the season, and they were supposed to have been alone in there. Melinda ran up the stairs to check and once again found the place to be deserted.

Shortly after Melinda Myers took over the operations of the Crew's Nest from her father, the back door to the billiard room by the restrooms was being discovered open every morning. A member of the staff started coming to her in the mornings to complain that the bartenders had been leaving this door open. Melinda explained that the bartenders never used that door and therefore could not have been responsible for it being left open. Still, the bar staff started to get reprimands over this matter, even though they denied having gone through that door. Eventually, at the end of the night, two of the bartenders would supervise the closing of this door. One would close it, and the other would check to make sure that it was closed and locked. Still, the next morning, there would be the door, unlocked and wide open. To solve this problem, a deadbolt was finally installed on the door. This seemed to do the trick. The door no longer opens in the middle of the night of its own accord.

Another person who has had a few experiences here is Bridge Francis, an employee of the Crew's Next and longtime family friend of Melinda Myers. Late one night, at around one or two o'clock in the morning, Bridge was in the downstairs lounge of the Crew's Nest and had been closing up with two other members of the staff. All of the guests had gone home for the night, and the three of them were quite alone in the building. Shortly before getting ready to leave, they heard what sounded like someone upstairs in the restaurant rolling silverware. When time permits, the staff would roll forks, knives and spoons together in napkins to be placed on the tables of the dining rooms. The sound of this chore makes a distinct clinking noise. Bridge had been upstairs many times by himself, so when one of the other two dared him to go up and check things out, he thought nothing of it. When he reached the top of the stairs, he could still hear the sound of silverware being moved around and clinking together but noticed that it was coming from the office. As soon as he turned and peered into this office, the sound stopped at once. He returned downstairs

and shared this experience with the other two members of the staff who had stayed behind. The three of them left the building soon after.

During the spring of 2016, one of the staff members was walking along the side of the building and, for the briefest of moments, noticed someone sitting in a chair in the side window upstairs. He stopped and took a step back and looked back up into the window again. The figure had vanished entirely. He went directly upstairs to investigate but found nobody there. The entire upstairs was completely devoid of people. What's more, there wasn't even a chair placed anywhere near that window.

Another story that Melinda Myers related was one regarding a day that she had been doing some spring cleaning in the attic. It should be noted here that the attic of the Crew's Nest is said to be the center of the majority of paranormal events in that place. When Melinda finished with the task of cleaning the vast space, the room was immaculate. Later that afternoon, she came across a black rubber rat sitting in the kitchen, a Halloween decoration that had been left out as a joke since the previous autumn. Upon finding it, she took the rubber rat, walked halfway up the attic stairs and tossed it up into the darkness. A moment later, the rubber rat came tumbling back down. She knew for a fact that there was nothing up there for it to have hit and bounced off of. She picked it up off the floor and threw it up there again, and again it was tossed right back down. At this, she yelled "Stop it!" and threw the rubber rat up there one more time. There it remained.

During the summer of 2016, Melinda was sitting outside with the chef when one of the cooks came outside to inform the chef that "it has happened again." Melinda Myers inquired as to what the cook was talking about. He explained that a few times, when the staff would come in to work in the mornings, one of the burners on the stovetop would be turned on at full blast. This particular summer day, the cook had left the kitchen for but a moment and the rest of the staff was in another part of the building. When he'd returned, the burner was lit again.

Some of the other staff members have reported lights tuning off on them while they're trying to work. The ghost at the Crew's Nest is jokingly called Spencer. The staff gave him this name simply because they have no idea what else to call him. A medium came out that same summer to cleanse the building. She firmly believed that the spirits in the Crew's Nest were simply a few late island residents stopping in for a visit or playing the occasional prank. Whoever it is that haunts this island clubhouse, one thing is for certain. They're certainly enjoying one of the most comfortable retreats that Put-in-Bay has to offer.

7

Inselruhe

Standing watch over the road that leads out to East Point from town is an impressive house called Inselruhe. This stately mansion was built in 1875 in the unique Steamboat Gothic style and was designed by architect James Young for a Toledo railroad magnate named James B. Monroe.

Monroe was born on November 10, 1826, in Canada. He came to the United States with his parents in 1834, at which time they settled in Norwalk, Ohio. It was there that Monroe established a successful dry goods firm called Monroe and Peck with G. Henry Peck. He married Mary Jane Morse-Hoyt in Norwalk, Ohio, on July 24, 1849. His bride's father was Leonard Morse, who died when she was quite young. Her mother remarried a man named William R. Hoyt, who had raised her.

James and Mary Monroe had one daughter, a girl they named Mary. By the 1860s, the Monroe family had relocated to Toledo, Ohio, where James entered the railroad industry. During the early 1870s, having amassed a considerable fortune in that trade, James B. Monroe relocated with his family to Put-in-Bay, where he purchased a twenty-acre vineyard. It was there that his daughter met Admiral J.J. Hunker.

John Jacob Hunker was born on July 6, 1844, in Pittsburgh, Pennsylvania, to parents Andrew Hunker and Margaret Donaldson-Hunker. John had followed his parents to Put-in-Bay, where they had established a hotel on Delaware Avenue called the Hunker House. For more on that, see the chapter on T&J's Smokehouse. John Hunker and Mary Monroe exchanged their nuptials in Toledo on December 22,

1875. They would have one child, a son named James, who was born the following year.

In all honesty, Inselruhe was actually a wedding gift to the bride and groom from James and Mary Monroe, as the Monroes never actually resided there. Monroe knew from the start that he wanted to give them a most impressive gift. With James Hunker being an officer in the U.S. Navy, a Steamboat Gothic-style house seemed appropriate. The men that he'd contracted to build this house were Adam Heidel and George Gascoyne.

Gascoyne had first come to Put-in-Bay in 1869 to build the additions for the first Put-in-Bay House. He remained on the island after the work on that hotel had been completed and soon found more work in the construction trade. In fact, most of the historic buildings in the village of Put-in-Bay can lay claim to having been constructed or remodeled by this well-respected builder.

When the home was complete and presented to the Hunkers, James Monroe gave it the name *Inselruhe*, which is German for "Island Rest." John and Mary Hunker primarily used this as a summer residence for when they came to the islands to visit their parents. John Hunker was a rear admiral in the U.S. Navy, which kept him away from home for long periods of time. During his tenure with the navy, he was the commander of the USS *Annapolis* and USS *Constellation*. The Monroes remained close to their daughter and her family until James B. Monroe's death in March 1896.

The Hunkers continued to occupy Inselruhe until Admiral John J. Hunker's death in Asheville, North Carolina, in 1916. It was at this time that Mary Hunker relocated to the Hunker Villa, a stately Italianate home that sat just to the east, which had been occupied by her late husband's parents. Mary continued to spend her summers at that house until her own death, which occurred in Los Angeles, California, in 1940.

Frank H. Miller and his wife purchased Inselruhe, which had always been a one-family home, in 1937. The house had six bedrooms and still contained most of its original furnishings when they moved in. Frank Miller had been, among many other things, a past commodore of the Inter-Lake Yachting Association. Furthermore, he had owned numerous boats, a few of which he kept in the elaborate boathouse that sat across the road from the house. Unfortunately, this boathouse was destroyed in a severe Lake Erie tempest many years ago. Miller also boasted about the many cars he owned. He and his wife were also the owners of two houses, one being Inselruhe at Put-in-Bay and the other being Ashlea in Glendale, Ohio. Both of these, he claimed, were old mansions in the grand manner, complete with towers,

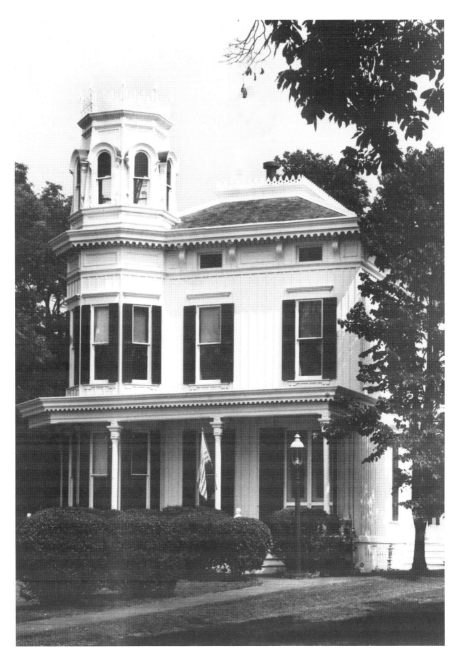

Inselruhe, German for "Island Rest," was built for the Hunker family in the Steamboat Gothic style and stands just to the east of the grounds of Perry's Victory and International Peace Memorial. *Courtesy of Maggie Beckford.*

The front foyer of Inselruhe offers visitors a warm and inviting setting. *Courtesy of Maggie Beckford.*

ghosts and history. Sadly, Miller would not go into the details of either haunting. When the Miller family ultimately sold the house, they left many of the furnishings for the new owners to care for and to keep with the property. Many of these items remain there to this day.

Inselruhe was officially listed in the National Register of Historic Places on December 12, 1976, as listing number 76001506. It is also listed with the National Historic Trust.

Two men who have lived there in the past seem to disagree with each other over the haunting. One says that he's never had anything happen to him at all, while the other says that he has. Unfortunately, like Frank Miller, he would say no more on the subject.

One island resident of more than thirty years has had multiple experiences while driving past this house. The first time he saw something, it was in the left-hand window of the house on the second floor. For a moment, he thought he had seen someone looking out at him, and the next moment, the figure had vanished. On a second occasion, he was driving by the house and this time distinctly saw the full form of a man looking back at him. He was dressed in curious attire: a white sailor's hat, a white shirt and a pair of grayish-blue pants.

The last time he saw the apparition, he was riding with a friend and again saw the man looking down at him. At this, he insisted that his friend drive faster. The old man's gaze was quite unsettling.

Details are sketchy about who or what might haunt Inselruhe, as no one wishes to elaborate on the events that take place there. A quiet stroll past this house on a warm summer evening might bring down a stare from above. It's all good though. Just keep walking.

8

GIBRALTAR ISLAND

No one ever said that a ghostly encounter had to be witnessed from up close. Take into consideration a story that appeared in the *Cleveland Plain Dealer* on May 16, 1926, regarding ghostly lights that seemed to emanate from Middle Island, which sits just inside the Canadian waters to the north of Kelleys Island.

Many throngs of people had been flocking to Middle Island or, as they called it, Devil's Acres. These visits came on the heels of reports that mysterious lights had been seen hovering above that island. At the height of the Prohibition era, it was believed that the lights were actually the campfires of bootleggers who were using the island as a last stop on their dangerous run of booze into the United States. Another thought was that perhaps someone was stranded on the island. A search party was sent over, but rescuers found no trace of anyone having been there for nearly a year. Seeing these phantom lights on Middle Island was nothing new.

Just two moths earlier, there had been a disappearance of an entire family on the lake. James Phipps, his wife and three children lived in Leamington, Ontario, and decided to drive across the ice on Lake Erie that winter to visit Mrs. Phipps's mother, who resided on Pelee Island. At the close of their visit the following morning, a blizzard had come up. Despite warnings, James decided to attempt the perilous crossing. Forty-eight hours later, the disappearance of the family was flashed abroad, and search parties were organized. Every inch of that ice was searched, and an airplane was brought in to cover the area where it was now believed that the entire Phipps family

had gone to their deaths. The family was never seen again, and no bodies were ever recovered.

Ten days later, mysterious lights were seen over on Middle Island. Thinking that perhaps the Phipps family had gotten misdirected on the ice and made it as far as that piece of land, a group of men were assembled at Kelleys Island to go out and investigate. The search party set out on March 21 and reached the fifty-acre island by midday. Once they arrived, they found themselves baffled to no end. A search was made of the entire island, and no trace of a signal fire could be found, not even a single charred log. Even the old lighthouse, which the Canadian government had abandoned the previous year, showed no sign of having been used as a shelter.

Another story was related regarding these mysterious lights on Middle Island by Edith Brown Alexander, wife of Put-in-Bay mayor T.B. Alexander. Many years earlier, her cousin Lemuel "Lee" Brown had been the owner of Middle Island. According to Mrs. Alexander, her cousin had come over to visit her father and shared with him a rather wild story. He had been gathering wood along the shore of that island that morning. While returning to the house, he had reached the center of the island and it was there that a tall flash of light appeared directly in front of him. At first, he thought that the house was on fire. He dropped the wood and ran toward the building. Within a short distance, he could see his house clearly and noticed at once that there was no smoke coming from it. Immediately, the column of fire disappeared. That afternoon, he returned to the shore and saw the fire again. Brown claimed to have seen this mysterious light many times at night but never in the daytime.

During the summer of 1925, the island's owners, Sid Bellows and Bruce Bell, hired a boat to take them from Toledo to their island in the middle of the lake. Upon arrival, they dismissed the boat and decided on an extended stay. Some time later, a gale sprang up, and the two men soon heard a distress signal. They discovered a disabled boat just off shore that had been caught in the sudden storm. After rescuing the occupants of the boat, they realized that they would need assistance in leaving the island. They lit a signal fire, but it went unanswered. Some days later, the boat that had brought Bellows and Bell to Middle Island returned and carried them home. When the men inquired as to why no one had come to their aid prior to this, boatmen on Kelleys Island replied that they had believed the signal fire to be more of those weird lights that often appear on that island.

A similar story of a phantom has emerged across the waters of Put-in-Bay, over on Gibraltar Island. Gibraltar was among those islands that were

purchased in 1854 by Joseph De Rivera St. Jurjo. A few years later, De Rivera was approached by a man named Jay Cooke who expressed interest in purchasing this island. When asked how much he wanted for the little island, De Rivera gave him a figure of $3,000. Cooke informed him that he would do him one better and purchased the island for $3,001.

Jay Cooke was born in Sandusky, Ohio, on August 10, 1821, to Eleutheros Cooke and Martha Carswell. In his life, he became a wealthy banker in Philadelphia, Pennsylvania, and invented the concept of war bonds. Through this idea, he was able to raise $1 billion to support the Union army during the Civil War. At the close of the war, he erected a fine summer residence on Gibraltar Island, which to this day is known as Cooke's Castle.

The island itself is really quite small, comprising only about six and a half acres. It acts as a natural lee to protect the waters of Put-in-Bay. This was one of the primary reasons that Commodore Oliver Hazard Perry selected the harbor as his base of naval operations in the days leading up to and immediately following the Battle of Lake Erie. Prior to Cooke's purchase, the island had been used as a burial site. Aside from the funeral that Daniel Vroman attended, which was mentioned in the chapter on the Put-in-Bay Winery at the Doller Estate, it is also the resting place of James Ross, who died on August 11, 1848, and John Elliott, who died thirty-seven days later. Today, Gibraltar Island is owned by the Ohio State University and serves as the home of the Franz Theodore Stone Lab, the oldest freshwater biological research center in the United States.

One story about this island that stands out above most is the sad tale of Annabelle Mavis. This story was told to John Domer, who made his introductions in the chapter on the Park Hotel. John was told this story by a Put-in-Bay old-timer not long after he had first arrived to the island. It was reinforced by others who had made similar claims.

The story goes that Annabelle Mavis was a daughter of one of the cooks who worked for the Jay Cooke family on Gibraltar Island. During this time, just after the close of the Civil War, he kept a rather large staff of housekeepers, gardeners and cooks at his residence. Annabelle, for her own part, was quite a beautiful young lady in her mid- to late teens. While not officially a part of the staff, she would still help her mother out in the kitchen from time to time.

Every once in a while, Cooke would have a courier sent over from Put-in-Bay to deliver messages for him. Sometimes, the courier would spend the night, and other times he would simply drop off the messages and leave. Occasionally, he would have to wait a considerable amount of time for

Cooke to reply to his correspondences before returning to Put-in-Bay. One such courier was a young former Union soldier who had served during the recent war. While spending a great deal of time on the island waiting for Mr. Cooke to reply to his messages, this courier had gotten to know young Annabelle Mavis quite well. The two became friends and soon fell in love.

On one trip over to Gibraltar, the courier brought a gift for Annabelle with him. He presented her with a small locket that contained his picture and a lock of his hair. Upon giving her this locket, he told her that as long as she wore it, he would know that her love for him was unending and she would want to be with him always. She immediately placed it around her neck, swore that she would never take it off and vowed that when she came of age she would marry him. After this, the courier continued to bring messages to Cooke, and whenever time permitted, he would steal away with Annabelle and spend his hours alone with her.

One evening, while Annabelle's true love was away from the island, one of the members of the gardening staff managed to get Annabelle alone on a remote part of the island, the highest point to the east, called Perry's Lookout. It was from these high cliffs that a detachment of Commodore Perry's men had been stationed as lookouts prior to the Battle of Lake Erie. While strolling these bluffs with Annabelle, the gardener tried to have his way with her. She fought him off as best as she could, but in the struggle, the locket was torn from her neck and tumbled over the edge of the cliff.

The next day, her beloved courier returned, and to his heartbreak, he immediately noticed that the locket was gone. At this, he refused to see her, let alone even talk with her. To complicate matters, Annabelle was terrified to explain what had happened the previous evening. She didn't know what was worse, her courier being heartbroken over the absence of his locket or him despising her for being ravaged by another man. It must be remembered that this was a different time, and a woman who had been handled thusly might be thought impure.

Annabelle Mavis, with a lantern in her hand, spent that entire night climbing among the rocks and little beach below the lookout, making a vain search for the locket that was the symbol of her love. The next morning, the courier departed Gibraltar Island never to return. Despite this, Annabelle continued to search for the locket, but all attempts to recover it proved fruitless.

The fate of Annabelle Mavis is unknown. Whether she died young of a broken heart, moved away never to return or married another is unknown. It is said that some years later, on very calm nights, people looking over

Perry's Lookout on Gibraltar Island, circa 1904. It is here, among the rocks, that the spirit of Annabelle Mavis is said to continue her eternal search for her locket. *Courtesy of the Library of Congress.*

from Put-in-Bay began to see the glow of a lantern and the apparition of a young woman climbing among the rocks of Gibraltar Island below Perry's Lookout. It was immediately believed that this was the spirit of Annabelle Mavis, trapped somewhere in time, still searching for that locket. If the waters are completely calm and there is no wind to speak of, witnesses to the phantom could also hear her weeping while she made her eternal search.

After hearing this story as told by John Domer, a thought was put forth to discover if there was, in fact, any historical documentation to reinforce this tale. After tireless hours of searching, no record to prove even the existence of Annabelle Mavis could be found in any document or census record. That doesn't necessarily mean that she didn't exist. It may very well be that she resided on the island during the period when Jay Cooke was briefly in financial ruin. His bank had gone under, and he was, for a time, forced to sell the island to another family. He did reacquire Gibraltar Island some six years later, after his investment in the Northern Pacific Railroad brought in good returns.

It is true that this story could very easily be chalked up as a tall tale, very similar to the one about John Ohlendorf and his phantom Model A Ford, except that it has been repeated by many and was handed down to John Domer as best as it could be. Perhaps the name and circumstances have been altered or exaggerated as the telling of it was passed on, but for so many people to have laid claim as witness to the apparition of this girl seems unlikely that it is the fabrication of an overactive imagination.

9

PERRY'S VICTORY AND INTERNATIONAL PEACE MEMORIAL

One of the most recognizable features of Put-in-Bay is Perry's Victory and International Peace Memorial. This national monument was built between the years 1912 and 1915 for two very different reasons. Firstly, it serves as a memorial to honor those brave men who fought with Commodore Oliver Hazard Perry at the Battle of Lake Erie on September 10, 1813. It also honors the peace that the United States now shares with the nations of Canada and Great Britain that has endured for more than two hundred years since the conclusion of the War of 1812.

The memorial, which happens to be the most massive freestanding Doric column in the world, towers an astonishing 352 feet above the surface of Lake Erie. The commanding view from the observation deck, which sits at 317 feet above the lake, offers a panoramic vista of the western basin of Lake Erie as well as the surrounding islands. From here, visitors can see the mainland of Ontario, the Michigan coastline and many islands that also sit in Canadian waters. On the clearest of days, the Key Bank building in downtown Cleveland, almost sixty miles distant, can be seen on the eastern horizon. The observation deck also overlooks the site of the battle of Lake Erie, just east of West Sister Island, as well as a portion of the U.S. and Canadian border, which also happens to be the longest demilitarized border in the world.

Overall, Perry's Victory and International Peace Memorial is the third-tallest national monument in the National Park Service system, with only the Jefferson National Expansion Memorial, more commonly known as the Gateway Arch in St. Louis, and the Washington Monument being taller.

Still, considering the fact that both of these only offer their views through windows, Perry's Victory is the tallest open-air observation deck in the National Park system. It is also the only international peace memorial in the United States. It is operated and maintained by the National Park Service.

Ever since the 1850s, there had been a push to have a monument erected to honor Commodore Perry's victory at the Battle of Lake Erie. The original site chosen for this was on the eastern bluff of Gibraltar Island in 1859. A magnificent design was put forth and a cornerstone was laid, yet the funds to build such a structure were never raised and the movement lost steam. A few years later, the idea was revisited, but again, the finances fell short. It wasn't until the early twentieth century that a commission—composed of representatives from nine states and the federal government—was assembled to raise funding and oversee the construction of the Perry Memorial.

Realizing that Gibraltar Island lacked the space needed for such a monument, a new site was chosen: a swampy isthmus on South Bass Island that connected the main part of the island to East Point. Construction began in October 1912 with the removal of old tree stumps, filling in the wetlands and pouring the foundation. On Independence Day of the following year, a grand ceremony was held on the site for the placement of the cornerstone. This ceremony was followed by another, even grander one that September. A few days earlier, an excavation was done in De Rivera Park at the burial site of the fallen officers from the Battle of Lake Erie. What could be found of their remains was accompanied by a large funeral procession from the village park to the memorial. Here, the remains were repatriated in a tomb beneath the floor of the memorial's rotunda. A stone at the north entrance to the memorial column marks the site of these remains. The memorial was opened in June 1915 and was dedicated as a national monument in 1936.

The names of the killed and wounded from the American naval squadron that participated in the Battle of Lake Erie are engraved into the Indiana limestone that adorns the interior walls of the rotunda. The information provided here tells us that twenty-seven Americans were killed in the action, with ninety-six being reported as wounded. Of these ninety-six wounded men, seven expired from their injuries in the days that followed. An eighth man listed, a marine private named Henry Van Poole, died from typhus with another marine named Richard Williams on the return journey back to Erie, Pennsylvania, twelve days after the battle.

Located to the west of the memorial is the Rangers Operations Center, commonly referred to as the Roc. This building, a small one-story structure, was originally used as a shower house for the nearby

A concept design for the Perry Memorial from before ground was broken on the project, circa 1912. The two outlying buildings that flank the column, the Colonnade on the right and the Temple of Peace on the left, were never built. *Courtesy of the Library of Congress.*

bathing beach at the end of Delaware Avenue. During the early part of the twentieth century, this bathing beach offered water slides to thrill-seeking island visitors. It is here in this former shower house, in the dead of winter, that rangers have reported the mysterious sounds of footsteps while no one else is present in the building. One ranger reported the odd sensation of constantly being watched.

As for the memorial itself, it has had its own run of unexplained activity. One ranger, whom we'll call Martin, was working at the ticket desk at the elevator landing on the floor just above the rotunda. It was Martin's first day working in the capacity of fee collector, and the visitation to the memorial, compared to most bustling summer days, was relatively slow that afternoon. Sitting by himself and reading up on the history of the Battle of Lake Erie, Martin suddenly heard a loud banging sound from across the room. He looked up from his book to discover that one of the velvet green ropes, used to keep visitors by the ticket desk and from blocking the exit of the elevator, had been

removed from its stanchions and was lying across the room, in front of the elevator, about six feet from its place of origin. Martin nervously looked around for a moment, half expecting another ranger to be nearby, playing a trick on him. It wasn't long before he realized that he was quite alone. Shrugging it off, Martin walked across the room, picked up the green velvet rope and returned it to its stanchions. Perhaps this was his initiation, he thought.

Another event that was witnessed by many visitors was reported in 2015. It was late one morning, still rather early in the season, that the memorial was being visited by a large group of students from an area school, as is common throughout the late spring and early fall. This one group in particular had witnessed someone walking around on the maintenance level above the elevator landing and ticket desk. Their initial belief was that one of their fellow students had slipped past the fee collector at the ticket desk and ascended the stairs to the maintenance level above. This would have been rather hard to achieve, considering that there's a caged gate near the top of the second flight of stairs that is always kept locked. If anyone were to have gone up to that level, they would have needed a key to do so. The fee collector at the ticket desk suspected that it may have been someone from the maintenance department doing work up there. A radio call was made over to maintenance to confirm this, but the maintenance department denied that anyone had gone up to that level. Still, many visitors witnessed what seemed to be a person walking around in the dark above them.

It's a sad fact that many large-scale projects also see the occasional tragedy occur during their construction phase. Perry's Victory and International Peace Memorial is no exception. The fact is that there were two lives lost while the monument was being built. The first of these was the death of a man named Antonio Fabianto. Fabianto, an Italian by birth, was killed late in the afternoon of May 15, 1914, when a brick fell on him from the top of the column, then 215 feet high. He was killed almost instantly. The second death occurred on November 24, 1914, when a thirty-one-year-old skilled laborer named George Cochran of Toledo was killed by a block and tackle that had fallen from the top. Cochran had been working on the memorial for more than a year at this point and had just received his final pay. He was expected to return home to Toledo that evening.

There has also been one death in connection with the monument that occurred many years after the construction was complete. This tragic event in the monument's history occurred on December 11, 1980. Donald Hanley, age fifty-two, of North Olmsted, Ohio, had been working on the scaffolding that surrounded the column during a renovation phase. While

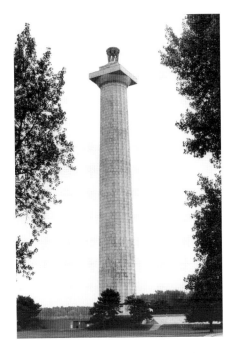

The 352-foot-tall column of Perry's Victory and International Peace Memorial as it appears today. *Courtesy of Maggie Beckford.*

working a considerable distance above the plaza, Hanley lost his footing and fell.

One odd and rather dark question that park rangers on the observation deck of the memorial are occasionally asked is if anyone has ever fallen or jumped from the top. Interestingly, they usually ask this while standing on the south side of the observation deck, while looking over the vast expanse of Lake Erie. The answer to that question is an alarming "yes."

At about one o'clock in the afternoon of July 27, 1945, a woman ascended to the top of the monument with eleven other sightseers and a guide. The group was on the north side of the platform when the woman left them, unnoticed, and walked over to the south side. From there, she pulled herself up onto the three-foot-high parapet wall and jumped. Two women and a man on the plaza below narrowly escaped being struck by the hurling body. The force of the impact was so traumatic that her features were entirely obliterated, and her remains covered a roughly 2,500-square-foot area. It was originally believed that the woman was between the ages of thirty and forty. Ottawa County coroner George A. Poe and county sheriff Ralph Reidmeyer were hoping to rely upon fingerprints to identify the woman, since the body virtually exploded upon impact and her fingers were about all that remained intact.

The following afternoon, a positive identification was made. William J. Lester of Hazel Park, Michigan, confirmed that the remains were those belonging to his eighteen-year-old daughter, Betty.

According to Lester, his daughter had been mentally ill for the last eighteen months and was despondent at times. He went on to explain that Betty had left Detroit the previous morning with her fifteen-year-old sister, Helen, and a friend, on a boat bound for Cedar Point. The boat had made a brief stop at Put-in-Bay, and all three girls disembarked. When Helen and her friend

An eleven-ton bronze urn crowns the top of Perry's Victory and International Peace Memorial. Despite popular assumption, the urn never contained a rotating light—such as a lighthouse might have—nor has there ever been a flame burning on the top of it. *Photo by the author.*

stepped back on board the vessel, Betty was not with them and was nowhere to be found. They suspected that she had changed her mind about going to Cedar Point and had decided to spend the afternoon on South Bass Island. Believing this to be the case, the girls planned to catch up with her when the boat stopped back at Put-in-Bay on the return trip to Detroit. When Betty didn't return to the vessel that evening, the girls reported her missing upon their arrival in Detroit. Mr. Lester made the trip to Put-in-Bay the following morning, where he learned of the suicide. From there, he took a ferry to Port Clinton, where he undertook the grim task of identifying the remains as those belonging to his daughter.

As mentioned in the introduction to this book, it is impossible to know who or what exactly haunts a site. All that can be gleaned are the stories of those who lived and died at such places. Perry's Victory and International Peace Memorial has seen four lives meet with tragic ends. Furthermore, there are six naval officers interred beneath the floor of the rotunda. Who can really tell who or what is responsible for the mysterious events that transpire at this national landmark?

PART III

AN EVENING OUT

10

PASQUALE'S CAFE

Before we spend an evening out, enjoying the night life that South Bass Island has to offer, it's probably best to take some time to enjoy a fine dinner. One place that would be great for that is Pasquale's Cafe. Famously known for their all-day breakfast, which aside from serving traditional eggs benedict and lobster benedict, also offers guests the "Hot Mess" and the "Kitchen Sink." Your mind can dwell on those for a few moments. In the afternoon and evening, a mix of American and Italian dishes are also available.

This family-friendly establishment originally housed an ice cream parlor and later served as the U.S. Customs Office for anyone arriving at the island from Canadian ports. Eventually, it was converted into a barbershop by a man named Harry Bannister. Within a few years, this barbershop would be sold to Michigan native Bernard McCann, who continued to operate it until his death on January 4, 1938. Upon his death, the business was taken over by his son, Bill.

Bill McCann was born at Put-in-Bay on December 11, 1912. Prior to taking over his father's business, he worked as a laborer doing odd jobs around the island, but the life of a barber seemed to suit him. Being a barber keeps one in touch with the community, and he was often seen actively conversing with his customers. At this time, the McCanns occupied the apartment above the barbershop. The entrance was located in the front of the building, through the door just to the west of the barbershop entrance. A set of stairs led into the upstairs living space.

When business was slow, Bill McCann could often be found sitting in his barber's chair reading the newspaper. It was on one such occasion in May 1962 that a friend happened to be passing by the shop and noticed Bill, with his paper, sitting in the chair. The friend stepped into the barbershop and warmly greeted Bill, but there was no reply. It seemed as though Bill had fallen asleep in his chair. The friend called out to him again, but once more, there was no reply. He went over to check on Bill and discovered that he had passed away while sitting in his barber's chair reading the paper. Incidentally, this is the same barber's chair that once graced the lobby of the Park Hotel and now sits in the foyer of the Red Moon Saloon.

It was known across the island that Bill McCann was a very talented violin player. Many times, passersby on Delaware Avenue below would hear him upstairs playing a lively tune. Shortly before he passed away, Bill had gotten into some sort of an argument with his wife, Juanita, over the violin playing. At this, he hid his violins somewhere in the building. As he hadn't told anyone where he'd put them, he carried the secret location of his violins to the grave. After his passing, the family was trying to decide what to do with some of his belongings, including his violins. The only problem was that no one knew where he had stashed them. A thorough search was made, but it yielded no results. The family simply figured that they were tucked away somewhere and would turn up soon enough.

A few months later, Juanita McCann approached her son and was quite pleased to learn that he had located his father's violins. Her son, however, was quite baffled by this assumption. He had done nothing of the sort. She was now very confused. She explained that the previous night, she had distinctly heard him playing one of his father's violins. Her son insisted that the violins were still missing and she must have imagined it.

Two weeks later, the violin music was heard again, and once more, the son denied having found either of the violins. Eventually, more and more people began to witness hearing the sound of violin music being played in the building. The music continued to be heard for more than twenty years after Bill McCann's passing.

Many years later, there were some renovations on the building. It was during this time that a stairwell was added to the back of the structure while the ones in front were removed and the space downstairs expanded. While removing the stairwell in the front, a hidden space was located above a small closet that sat beneath them. Here, in this space, were hidden Bill McCann's two violins. Upon their discovery, the violin music ceased for good. Those

violins are now in the possession of Bill McCann's granddaughter Melinda Myers. They remain silent to this day.

Even though the building is no longer filled with the occasional sound of a violin, that doesn't mean that all activity has ceased. John Domer explains that when he first came to the island many years ago, this place was called the Snack House. Shortly after, the name was changed to Pasquale's Cafe and has remained so ever since. John ran Pasquale's from 1990 to 1991 and had quite a few experiences to share.

Late at night, when John Domer was closing up, one of the ceiling fans would start to slowly spin of its own accord, even though it wasn't turned on. At this, John would kindly greet Bill McCann, and the fan would stop. After a while, another fan would pick up where the previous one had left off.

Another incident that is commonly reported is that of the overactive touch-screen cash registers. Once in a while, these computerized registers become active after being in sleep mode for some time. In order for this to happen, someone actually has to tap the screen. It is also certain that a power surge isn't causing this either. Were that the case, all of the registers would become active. In this case, it was only one. Sometime later, after the first would reenter sleep mode, another would come on. Very much like the fans, various other items in the restaurant will turn on and off sequentially.

John Domer further recalled that on occasion, certain items would fall off the shelves in the back room. What's more, when he opened the business in the morning, he often discovered an item in a completely different place than where he had set it the night before. John was always the last one to leave at the end of the night and the first to show up in the morning. There would have been no one else but him in that restaurant during the night. He likes to believe that it is Bill McCann playing the occasional prank.

Joe's Bar and Restaurant?

As we head out of town on Catawba Avenue toward South Bass Island State Park, we eventually come to Joe's Bar and Restaurant. The name of the place is titled with a question mark following the word *restaurant*, as that aspect of this establishment could easily be brought into question. It certainly is a bar, there's no doubt about that, and while it does serve food, an actual dining room is not readily available. There are a few tables inside, as well as an outside deck. Picnic tables grace the fenced-in yard below this, as do cornhole boards. Joe's is famous for a number of items on its menu, including, but not limited to Bloody Marys and the Sloppy Scotty. Calling the latter a unique take on a chili dog would be an understatement. The walls are adorned with a great number of license plates, most of which make a reference to island life. Also, live entertainment can be enjoyed on various nights during the week.

This little red building is by far one of the most unique on the island. It was actually built in two phases. The earliest section, the one that sits closer to Catawba Avenue, was originally an icehouse. This section was erected in 1865. The walls were once two feet thick and packed with sawdust for insulation to keep the ice from melting through the summer months. Two years later, the other part of the building was added. This section served as a press house, where grapes would be pressed into juice for wine. The man who started all of this was Max Van Dohren.

Van Dohren, whose name also appears in some records as Marx Von Dohren, was born in Denmark in 1829. He arrived in Cleveland in May 1851

and resided there with his wife, Charlotte, for about the next ten years before coming to Put-in-Bay. Van Dohren seized the opportunity to grow grapes on the island, joining an ever-growing list of people engaged in that line of work. His vineyards were quite vast, and production was rather profitable. He originally lived in a house that sat across the road from where his press house stood but eventually built another right beside the winemaking facility.

Max Van Dohren passed away on January 15, 1881, and the winery was passed on to his daughter, Minnie, and her husband, Ed Keimer. It would eventually be passed on to William Market, who married Ed Keimer's daughter, Lena. It continued to serve as a press house through the mid-twentieth century, after which it was used as a storage building.

Then, in 1978, the property was purchased by Arthur Boyles Sr. According to Arthur, the building was in a severe state of disrepair at that time. There was a four-foot hole in the roof, it was infested with termites and the entire structure was sagging. According to his son Artie Boyles, there was sawdust all over the place. It was falling out of the walls in the section of the building that had been the icehouse. Also scattered about the place were all of the old winemaking implements, including a six-foot basket wine press. Arthur Boyles Sr. and his son Philip, whom we met in the first chapter of this book, spent about a year putting everything back

Ed Keimer and his ten-year-old grandson, Dick Keimer, pose for this photo in a juice wagon with Dan the horse in front of what would become Joe's Bar, circa 1919. *Courtesy of Joe's Bar.*

together. Once the roof was replaced and the building was stabilized, he opened it as the Press House Bait Store in 1979. Most of the locals simply referred to it as Boyles Bait Store.

Arthur Boyles chose to open this business primarily out of necessity. There was a definite need for a bait shop at that end of the island. At this time, Arthur was the superintendent of the South Bass Island State Park, and many people came down to the pier to go fishing. Should they run out of bait, they would have to return to town to acquire more. Having a bait store located closer seemed much more convenient. Another reason for the bait store was the fact that Arthur Boyles didn't want his two younger sons working in town. Working at the state park just up the road, he would be close enough to keep an eye on things.

From the start, the business was a success. His two sons earned more that first year operating the bait store than Arthur did working at the state park. The boys were also very creative when it came to the shop. They placed boards across the old wine press and converted it into a display counter for lures and other fishing gear. Originally, there was a refrigerator that stored the containers of worms. Denise Kaczmarek was all too familiar with handling these worms. Her grandparents were friends with the Boyles family, and at this time, the bait shop also rented out bicycles. This was before the arrival of golf carts on the island. She recalled being about seven or eight years of age and was trading off work for the use of a bike. Cases of worms would be shipped in from the mainland, and she would have to divide them into groups of a dozen and put them into the individual containers.

Once in a while, the fishermen who would come in would ask where they could also pick up some beer. Eventually, Arthur Boyles obtained a carry-out license and thus began the beer and wine aspect of the business. Soon after, Arthur started to sell groceries from the bait store. The name of the shop was then changed to the Press House Corner Market.

Arthur Boyles never entertained the idea of turning the business into a bar. The Castle Inn was located just around the corner, and a little farther down the road was the Skyway. There just wasn't a need for another bar over there at that time.

The Boyles family continued to operate the market until around 1985, at which time Arthur Boyles Sr. sold the business but retained ownership of the property. The first person to take over the reins was a man from Cleveland, but according to Arthur, that man wasn't very successful and ran the business into the ground. The next to try their hands at operating the

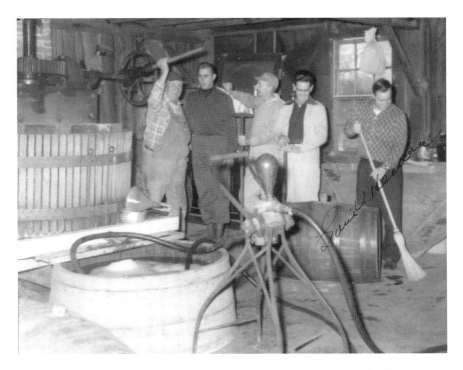

Left to right: Bill Market Sr., who was Ed Keimer's son-in-law; Jack Handwork; Tony Kindt; Kenny Chapman; and Louie Heineman pose for a photo in the old press house, circa 1955. Louie Heineman, who is sweeping the floor, is now the owner of Heineman's Winery, the oldest family-owned and operated winery in Ohio. *Courtesy of Joe's Bar.*

market was a couple from the Toledo area. Again, they weren't very good at running things, and the business suffered.

Finally, around 1998, the business was sold to Joe Suttmann, an English teacher who spent most of his time teaching in Germany. Joe did quite well with the business for some time. However, a few years earlier, the Castle Inn burned down, and he saw a need for a bar at that end of the island. Thus, he purchased the liquor license that had belonged to the Castle Inn and reopened the Press House Corner Market as Press House Joe's in 2003. Islanders simply referred to it as Joe's Bar, which stuck. To make room for the bar, Joe Suttmann sold the press to the family who owns Stonehenge, a historical home located on Langram Road. The old press has been fully restored to working condition and can be viewed at that location.

One of the most striking features about Joe's Bar is the downstairs rathskeller. This room is entirely of brick construction and boasts a vaulted ceiling, from which a small pipe extends. It was through this pipe that the

grape juice once flowed into barrels from the press above. Another unique part of the building is that while the side closest to Catawba Avenue has very thick walls, the other end of the building is of simple batten board construction. In some places, daylight can be seen between the boards. Thus the business closes down for the winter, usually in late October or very early November.

Joe Suttmann started to lose money on the bar and decided that a change was in order. He sold Joe's Bar to Mark Burr, Brad Ohlemacher and Mark Petroff, who are the current owners. They kept the name.

One person who could tell about a million stories about Joe's Bar is Jerry Percher, or Hippie Jerry, as he is more commonly known. Jerry can usually be found sitting outside the door to the deck on a partial picnic table against the building. This spot is affectionately referred to as Percher's Perch. Hippie Jerry was raised in Garfield Heights, Ohio, and came to the island in 1966 at the age of sixteen. Originally, he worked at a place called the Lighthouse Bar, which was operated by a couple from Florida named Marty and Jackie, who also ran the Crescent Tavern. It was at the Crescent that Jerry resided while working for them. The room he occupied was room 8, also known

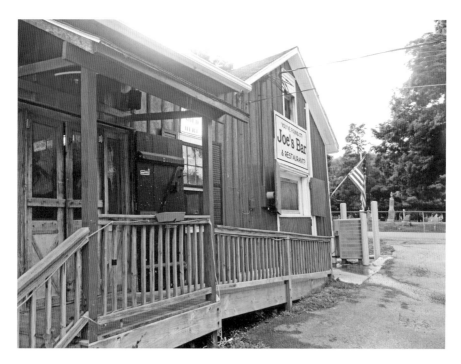

Joe's Bar as viewed from the same angle of the 1919 photo, as it looks today. *Photo by the author.*

as the T.B. Alexander room. For more on that, see the chapter on T&J's Smokehouse. He then worked for a time at the Wheelhouse, which is today the site of Misty Bay Boutique, and helped out as a handyman doing island maintenance with Gary Wilhelm, who lived across the road from Joe's.

Hippie Jerry also spent some time helping out as a stock boy for Arthur Boyles at the Press House Bait Store. He stayed on through the transition from bait store to corner market and even worked there while Joe Suttmann ran the place. Jerry recalls that Joe Suttmann, being an English teacher, would constantly correct everyone's grammar. Furthermore, he had such a mastery of the English language that he was able to insult someone's intelligence so eloquently they wouldn't even realize that he had done so.

Jerry recalls that there was originally only one restroom in the building. Women would often complain that there was no mirror in it, so a bench, table and mirror were placed outside the bathroom door. Today, there are two restrooms. Both are unisex.

Speaking of his own personal experiences at Joe's Bar, Hippie Jerry explains that on very calm days, when there's no wind to speak of, the doors to the bar tend to swing open on their own. Everyone in the place stops what they're doing and stares at the doors, completely dumbfounded as to the cause. Five minutes later, they would open again, this time in the other direction. Jerry would like to believe that it might be a former neighbor who once occupied the old Van Dohren house next door. Jerry had great admiration for this person and likes to think that they're just stopping in for a friendly visit.

Another experience that has been shared by many is the opening of another door in the bar. This door leads to the space upstairs and is located in the corner of the old press house section of the building. On one occasion in particular, one of many that have been reported, the door to this stairwell slowly swung open with no one there to lend assistance. One of the patrons got up from his stool and walked over to close it. To make sure that it was secure, he flipped the latch so that it wouldn't happen again. Regardless, the latch unfastened itself, and the door opened again just a few minutes later.

Arthur Boyles Sr. says that he never noticed anything unusual happening at Joe's Bar. The house next door, however, which he purchased when he bought the old press house, had plenty of activity. There doors would open and close of their own accord. Like Hippie Jerry, he also believes this to be a former occupant, just saying hello.

It should also be pointed out that located directly across Catawba Avenue from Joe's Bar is Crown Hill Cemetery, which was donated to Put-in-Bay by

Joe's Bar as it appeared during its years as the Press House Bait Store. *Courtesy of Maggie Beckford.*

Jose De Rivera in 1861. A burial here does date to 1859, that being Henry L. Foye, but he might have been moved from the first island cemetery, which as previously stated was located in the front yard of the Dodge House. Another headstone, for Sally Hill-Hyde and three of her children, was moved here in later years from the site that is now Tippers and the Beer Barrel Saloon. Mind you, the stone was moved. There's no mention of Sally or her children making the journey. Of course, there are others buried here in unmarked graves beneath the cemetery roadways, including Sam Anderson.

It's always a possibility that the restless spirit at Joe's Bar is any one of the late island residents interred in that cemetery. Perhaps they prefer the lively atmosphere of this local hangout to the quiet serenity of the graveyard. There seems to be a prankster in every crowd, living or deceased.

THE SKYWAY RESTAURANT AND BAR

If we could take a small trip back in time, one of the places we would definitely wish to visit would be the Skyway Restaurant and Bar. Located at 1248 Tri Motor Drive off of Langram Road near the airport, this was a very popular tourist destination back in its day. Throngs of weekend warriors would flock to the place, especially for last call, when the bars in town would close at 1:00 a.m. Nearly everybody in town now has a 2:30 a.m. liquor license.

The building that housed the Skyway dates back to 1878 and was built as a press house and wine storage building by a man named Dr. Lundgren. One of the most unique features of the building was that it was built directly above one of the many caves that dot the island. This cave in particular featured an underground pond. Later owners of the building would utilize this to their advantage. With the air in the cave a constant 50 degrees Fahrenheit year-round, a fan was set up to draw the air into the bar and restaurant to cool the facility. The only drawback was that the air was quite humid, and there was condensation on everything.

As mentioned in the chapter on the Put-in-Bay Winery at the Doller Estate, Terry Heidenreich purchased this island hot spot in 1980. He bought the place from Gene Bykowski and continued to run the establishment until 1998, at which time he sold the business to Don Thwaite and moved to Florida. Don was very forthcoming with a few stories from his time spent operating that once lively island destination.

He recalled one night when he and two other bartenders who worked late were there after hours. It was winter, and the bar had been set up with

couches and converted into something of a living room for the season. They had all been sleeping on the couches when they awoke to the sound of someone walking across the attic floor above them. Everyone was quite startled by this. Don assumed that someone had gotten into the building somehow and found their way into the attic. He went over to the attic door and called up, but there was no response. He ventured up the stairs but found the place deserted. After returning downstairs, he and his companions continued to hear the footsteps crossing the room.

Another incident that Don Thwaite shared involved a chef that once worked at the Skyway. This chef had been down in the basement early one morning when he saw a short man in a blue shirt. This shirt had a pocket protector that was filled with a few random small tools, a pencil and a pen. When he reported this to the owner, Don almost immediately had an idea of who the chef had seen. Frank was an island resident who had worked as an all-around handyman, primarily specializing in electrical, heating and refrigeration work. He serviced the appliances and units at the Skyway many times in the past. Sadly, Frank had passed away back in 1998, and this chef had never had the privilege of meeting him, until now at least, or so believes Don Thwaite.

On another occasion, it was reported that a bartender was closing up for the night and that all of the guests were gone and the doors locked. As he was getting ready to leave, a lady emerged from the back dining room. She stopped for a moment, glared at the bartender and continued to walk on. The bartender tried to follow her, but the woman vanished.

Don Thwaite sold the Skyway Restaurant and Bar in 2011. It has remained closed ever since. Today, the building serves as housing for a few employees of the Island Club. It hasn't been said if any paranormal activity continues to occur in the place.

THE PUT-IN-BAY BREWERY AND DISTILLERY

Looking back on the industry of alcohol production on South Bass Island, our thoughts turn immediately to the great number of wineries and vineyards that dotted the region. If it's more than a glass of Sweet Concord or Pink Catawba that you're craving, the Put-in-Bay Brewery and Distillery, at 441 Catawba Avenue, has you covered. Beginning in 1996 with brewing craft beer and adding a liquor still seventeen years later, this business proudly boasts the island's first brewery and distillery. Guests can pull up a stool in the grand barroom on the left or choose a table in the smaller and more intimate patio bar on the right. In either of these rooms, they can enjoy a West Shore IPA, South Bass Oatmeal Stout or even the unique Watermelon Wheat. Also available is an extensive food menu complete with appetizers, soups, salads and entrees. Two major crowd-pleasers are the Cowboy Burger and the Firehouse Pizza.

Such a friendly and inviting space would hardly seem to be the setting of a haunting, yet that belief couldn't be further from the truth. The Put-in-Bay Brewery and Distillery has its own resident ghosts—one for certain—but possibly as many as three. The majority of the activity in this establishment is attributed to a spirit known as Benny, but the question that begs to be answered is, who was Benny?

David Benjamin Rosenfeld, or "Benny" as he was known to his friends, was born in Lithuania in September 1867 and came to the United States with his family in 1882. Three years later, Benny was naturalized as a U.S. citizen. Then, in 1888, he arrived at Put-in-Bay as a traveling merchant,

The Put-in-Bay Brewery and Distillery as it appears today. The building was constructed in two phases. The section on the right originally was a store built by Benny Rosenfeld, and the section on the left was a service garage built by George Rittman. *Photo by the author.*

carrying with him little more than a peddler's pack on his back. A short time later, he acquired a horse and a wagon to transport the wares he sold. Finally, Benny Rosenfeld decided to become a permanent resident of the island and built a small frame shop on the corner of Delaware and Toledo Avenues. From there, he sold dry goods and notions. This first shop burned down around 1900, and Rosenfeld decided to build another small frame shop at the other end of the village. The site he chose was the empty lot on Catawba Avenue immediately across the alley that sits to the left of the village hall.

Benny Rosenfeld continued to operate a successful dry goods store at this location for a good number of years. Eventually, he outgrew the original frame structure and had it moved to the back of the lot. A new brick building was erected where the old one had stood. He also constructed a small frame office immediately to the left and adjoining this new building. These, too, he eventually outgrew. Rather than adding on to the structure even more, he decided to relocate to another. In October 1919, he purchased the roller-

skating rink building that had been built on the site of his first store on the corner of Delaware and Toledo Avenues. He sold his brick building on Catawba Avenue to a man named George "Butch" Rittman, who relocated from the Schiele Block a few doors closer to the bay and opened a grocery store and meat market in the building, one of the largest on the island.

Rosenfeld continued on quite well for some time at his new location on Delaware Avenue, but the Great Depression sent his business into a nosedive. During the 1931 season, he sold off what remaining inventory he had in the store. He was found dead in the back room of his shop on August 22, 1931, where he'd ended his life by hanging. His body was sent back to Cleveland for burial. David Benjamin Rosenfeld was fifty-three. He never married and left no family.

George Rittman, meanwhile, operated his grocery on the Catawba Avenue site for a good many years to follow. He even added a service garage to the building, replacing the frame office that Benny Rosenfeld built.

Eventually, the property was sold to the Township of Put-in-Bay, and the building was used to house the fire department. In 1995, after a new

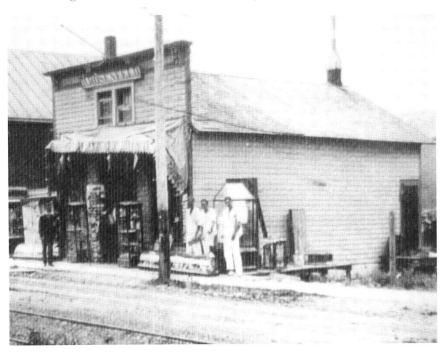

Benny Rosenfeld's first dry goods store on Catawba Avenue, circa 1910. *Courtesy of Put-in-Bay Brewery and Distillery.*

Right: George Rittman's grocery store in the late 1950s. *Courtesy of Put-in-Bay Brewery and Distillery.*

Below: This picture of Delaware Avenue shows Benny Rosenfeld's store on the far right with the framed office to its left, circa 1919. The building that sits to the left of this was the blacksmith's shop and now is occupied by the Old Forge. To the left of that is Rehberg's, which today houses the Reel Bar. *Courtesy of the Lake Erie Islands Historical Society Museum.*

fire station was built, the building went up for auction on August 13. The new owners were Chris and Carl Krueger. Carl, with his good friend Scott Jackson, worked through the winter and into the following spring, so that by May 1996, the brewery was up and running.

Today, the store that was built by Benny Rosenfeld houses the patio bar on the right-hand side of the building. The section of the Put-in-Bay Brewey and Distillery that contains the main barroom was once the service garage that George Rittman added.

It should be noted immediately that employees of the Put-in-Bay Brewery and Distillery are highly discouraged from talking about Benny. It seems that when they do, odd things start to happen around the place. General manager Tommy Dailey shared a number of the disturbances that have been commonly reported among the staff.

Tommy explained that Benny, it seems, loves to mess around with the electricity. He enjoys popping the light bulbs and screwing with the televisions and phone. If it's electrical, it's fair game for him. He even seems to enjoy flipping the circuit breakers on and off. Almost every day, at least one or two light bulbs seem to blow out in the restrooms. Every time the doors to these are opened, the lights come on automatically. This is when the bulbs would pop. It almost always happens in the morning.

Tommy Dailey shared a few other experiences that the staff have witnessed over the years. He related a story about one member of the staff having the coffeepot fly off of the coffeemaker and smash all over the floor. No one was standing anywhere near it. Also, in the past, there used to be a set of speakers that hung over the bar. These had been installed quite well and were securely fastened. Still, one of these speakers dropped on a bartender for no reason at all. They also used to keep growlers on a shelf above the bar. These are convenient for anyone who wishes to take home a jug of the fine craft beer they produce on site. It seemed that if something was going on that Benny didn't like, he'd push two or three of them off the shelf at one time. Growlers are no longer stored up there. It is also reported that the night cleaning staff has heard the most unusual sounds and have also seen items fall off the shelves of their own accord.

Someone else who has had an experience or two in the place is Kylie Simonds, who bartends and serves at the Put-in-Bay Brewery and Distillery. The most memorable event, she recalls, occurred around 9:30 one evening as she and co-worker Khloe Zolgharnain were rolling silverware on the patio bar side of the building. Kylie thought for a moment that there was a customer standing behind her, trying to get her attention for service. She

could only just see her out of the corner of her eye, but it was enough to know that she was a woman with long, flowing hair and wearing a dress. When Kylie turned to address the woman, she vanished. At that very moment, Khloe had also looked up and for the briefest of moments saw the shadowy image vanish. Both women were in utter disbelief, as both witnessed the apparition at the exact same moment.

There have also been reports of people seeing a little girl in the building. One to have witnessed this was bartender Ken Bodie. One day, as he was walking past the restrooms, he noticed a little girl standing by herself in front of the restroom door. Thinking it odd that a girl should be standing in a brewery by herself, he turned back and looked again. The little girl had vanished. Other members of the staff have reported similar incidents. She always seems to appear in areas of the building that aren't covered by the security cameras.

Located on the patio bar side of the building, leading off from a ledge high above the customer seating area, sits a little door that really seems to go nowhere. It's not very big at all, only about two feet in height and width. Anyone who goes into that side of the bar can locate it easily. It sits just to the left of the transom of a boat called *Big Ten*. This little door, for no reason whatsoever, likes to open and close on its own, even though there's no wind or draft to speak of and the small space behind it leads nowhere. One employee even managed to record the event during the summer of 2016. They had been filming a friend on their phone when somebody noticed the door opening. The person with the phone quickly turned the camera toward the tiny door and caught the rest of the event as it unfolded. Many believe that the spirit of the little girl hides in that space behind the door. The staff try to keep it closed at all times.

When he was closing up for the night, Ken Bodie, who was a little skeptical at first about the stories of the haunting, would on occasion try to get something to happen by calling out Benny's name and egging him on, hoping that some event would transpire. One night, at about 3:00 a.m., he was closing up the bar and had been doing just that while one of the security staff members was with him. After a few minutes of this, it seemed as through he struck a nerve. The door to the kitchen suddenly slammed shut and then started rattling for about the next thirty seconds. This terrified Ken to no end. He then thought perhaps that someone was either hiding back there or playing a prank on him. He asked the security staffer to go and check it out, which he reluctantly did, but the man returned to say that the place was empty. As with the little girl who randomly appears, the section of

This little door, located above the Patio Bar at the Put-in-Bay Brewery and Distillery, opens and closes without the aid of wind or hand. Some believe that the spirit of a little girl hides in the space behind it. *Photo by the author.*

the building where this kitchen door is located is not covered by the security cameras. What was captured on the security cameras, however, was Ken Bodie's expression of horror when the door suddenly slammed and started to rattle and shake. Reviewing this footage entertained the staff quite a bit. Needless to say, Ken no longer tries to contact Benny.

Of course, there's no way to know for certain if this is in fact the spirit of Benny Rosenfeld, who ended his life in 1931. The identities of the woman and little girl are also something of a mystery. Still, there is a definite presence at the Put-in-Bay Brewery and Distillery that cannot be explained. Perhaps it hides at night by the kitchen and restrooms, waiting for dawn to arrive to pop light bulbs. Perhaps it hides behind the little door above the patio bar. In any sense, it's best not to talk about Benny.

14

TOPSY TURVEY'S BAR AND GRILL

Island visitors can find one of the true treasures of Put-in-Bay located at 361 Bayview Avenue. Here sits Topsy Turvey's, where good times abound and the food and drink are quite possibly some of the best to be had at the bay. Guests can treat themselves to a dish of mussels in sauce or any number of daily lunch and dinner specials, but the big favorite seems to be the Cuban sandwich. Furthermore, Topsy Turvey's also offers a wide selection of craft beer. Many people who are looking for something a little different tend to gravitate toward the frozen Brandy Alexanders, the best on the island. The only way to describe this cocktail for anyone who is unfamiliar with it would be as a spiked frozen chocolate milkshake, generously topped with whipped cream and ground nutmeg.

The building also serves as an all-around gift shop, marine supply store and beer and wine carry-out. Visitors are immediately drawn to the thousands of dollar bills that grace the walls of this establishment. A Topsy Turvey's tradition is for visitors to sign their names to a dollar bill and staple it to the wall. Also available for visitors to rent are golf carts, one of the only ways to truly view the island. Furthermore, an espresso bar graces a glassed-in alcove up front, where islanders frequently come for their morning cup of joe. There's also a terrific outdoor dining area located in the rear and directly on the bay, which offers splendid views of the sunset over neighboring Gibraltar Island.

In front of the building, guests are treated to another fine outdoor seating area. It is here that live music can be enjoyed every Friday and Saturday night,

Employees (*left to right*) Sean William Koltiska, Jessica Cuffman Dress, Ida Gespaher and Bobby Hill pose for a photo in front of Topsy Turvey's in 2016. *Photo by the author.*

as well as Sunday afternoons, throughout the season. The conclusion of the weekend seems to culminate here for islanders, of all nights, on Mondays, with the Island Jam Night, hosted by Put-in-Bay entertainer Drew LaPlante. Island employees, who otherwise don't get an opportunity to perform on stage, are encouraged to come up and play or sing a few songs.

This historic structure started off as a boat livery owned by Valentine Doller, who also owned the large dock next door, which is now the Boardwalk complex. Here, visitors could rent small rowboats for fishing excursions or lazy afternoons out on the bay. The original building, which now houses the store aspect of this business, was built around 1872 as an open-sided frame structure. Some years later, the west end of the building was enclosed with batten boards and a small office installed.

Upon the death of Olga Doller, Valentine Doller's last surviving heir, the property was passed along to the caretaker of the Doller properties, John Nissen. For a time afterward, it was operated by the Ladd family of Put-in-Bay. Shortly before all of this, Ken Turvey invested in what would become the Crew's Nest with Marv Booker. During the 1970s, they took over the old boat livery and docks, adding them to the amenities that the Crew's Nest had to offer. At this time, the building was fully enclosed and operating as a marine supply and carry-out beverage store called the Yacht Shop.

Steamships pulling in at Doller's Wharf. The boat livery building that would one day become Topsy Turvey's sits to the right as an open-sided frame structure, circa 1906. *Courtesy of Topsy Turvey's.*

In the early 1980s, the Bookers and the Turveys sold their interests in the Crew's Nest to Mack McCann. As a part of this deal, the Turvey family would retain ownership of the Yacht Shop. It was at this time that the business was renamed the Wharfside, but it continued to sell marine supplies, island gifts and carry-out beverages.

In 1986, a major renovation was carried out on the building. The entire structure was raised by a significant amount to prevent flooding of the store. Water levels on Lake Erie were reaching an all-time record during the years leading up to this. The project proved successful, as the store no longer received water during the severe nor'easterly storms that pummeled the island.

Upon the Turveys' retirement in the early 1990s, the business was sold to their daughter and son-in-law, Suzanne and Robert Hill. The Hills ran the store until 2006, at which time they passed it along to their sons, David and Bobby. Two years later, Bobby sold his half of the business to his brother but stayed on as the seasonal kitchen manager. Bobby Hill spends his winters in Key West, Florida.

In the summer of 2013, a bar was added to the back of the store, and thus Topsy Turvey's was born. Two years later, a wall facing the store was removed and the bar area enlarged, offering more seating available to guests.

Many people have had unexplained incidents happen to them at this establishment, but one who was willing to share his experiences was Sean William Koltiska. Sean, a native of Westlake, Ohio, works as the nighttime bartender at Topsy Turvey's. Oftentimes, he is alone in the bar at the end of the night, cleaning up, turning off the music and the fans and counting the money in the register with the place locked up. It is at this time that most events occur. These usually come in the form of the sound of footsteps echoing throughout the building, an event that is reported by many others who have worked there. Also to be heard are the occasional knocking sounds, as well as the sounds of something falling over in the kitchen. When Sean would go to investigate, he'd find everything still in its proper place.

One night, while he was closing up with Bobby Hill, they were alone in the bar when they suddenly heard the door that leads from the back hallway to the outside open and slam shut. This was rather alarming, as the two men were supposedly the only ones in the building. Bobby went out the front door to see if anyone was leaving the building while Sean went to the back hall to see if anyone had come in. Both were shocked to see that no one had done either. They both circled the building to see if their mysterious visitor had slipped down to the docks behind the building or was hanging out among the golf carts parked on the side. Again, no one could be seen.

Another occasion that Sean recalls occurred when he was just about to close up for the night and go home. He had just turned out all of the lights and was making his way to the door that leads off of the back hallway to the outside, the same one that he and Bobby Hill had heard open and close on its own. As he entered the darkened corridor, he heard the sound of footsteps approaching him rapidly from behind. Sean stopped dead in his tracks and could even feel the footfalls as they quickly drew nearer. The footsteps came right up to his heels, and there they stopped. Too terrified to turn around, Sean screamed and fled the building as fast as he could.

One of the most memorable events in Sean Koltiska's memory occurred on the night of August 13, 2016. Again, it was near the end of the night, and at this time, there were only a few people in the building. Sean had been in the kitchen for a few minutes putting something away. As he stepped out of the kitchen, he glanced down that same back hallway. Here in the passage, a number of boxes, full of restaurant supplies, had been stacked. They had received a delivery earlier, and the items still needed to be put away. Leaning against these boxes was an elderly man, whom Sean described as wearing a white short-sleeved shirt. A moment later, the apparition vanished right before his eyes.

The boat livery in the 1960s after being enclosed. The three windows on the far right of the building still exist today and face the scenic back deck. The section on the left is now occupied by the barroom. *Courtesy of Topsy Turvey's.*

It's hard to know for certain who or what haunts the old boat livery. What is known is that at least three of Valentine Doller's buildings are haunted. That may be a record. So if it's great food, specialty drinks or live entertainment that you seek, then Topsy Turvey's should definitely be on your list of places to check out. Just do yourself a favor and avoid the back hallway around closing time.

THE REEL BAR

A fairly recent addition to Put-in-Bay is the Reel Bar, located at 461 Catawba Avenue. This newer island hot spot has rapidly grown a fantastic reputation for its live music venue featuring such performers as Bob Gatewood and Ray Fogg, to name a few. It also has gained acclaim for its menu, which features Lake Erie fish and some of the best burgers on South Bass Island. Though it is a new business, the building itself is actually quite old. In fact, it's well over one hundred years old. It's what the owners like to call Put-in-Bay's newest old bar. The building that now houses the Reel Bar dates back to 1906, when it was built by the Rehberg family.

John Rehberg Jr. was born on Middle Bass Island on April 30, 1864, to parents John Freidrich Helmuth Rehberg and Sophia Maria Warrnke. His parents, both German immigrants, came to the United States in 1853 and first settled in Chicago, Illinois. After a few years, they briefly resided near Cincinnati, Ohio, before returning to Chicago. After a few more years in that city, they continued on to Indiana, where John Rehberg Sr. was engaged in farming. Eventually, the Rehbergs continued to Ohio, where they settled on Middle Bass Island. A few years earlier, John Rehberg Sr.'s brother, William "Count" Rehberg, had purchased the entire island from Joseph De Rivera St. Jurjo, and it was at the request of Count Rehberg that John came to reside on that island.

John Rehberg Jr. was married on November 19, 1890, to Julia Bretz. Within a few years, the couple removed to Put-in-Bay, where John took a job

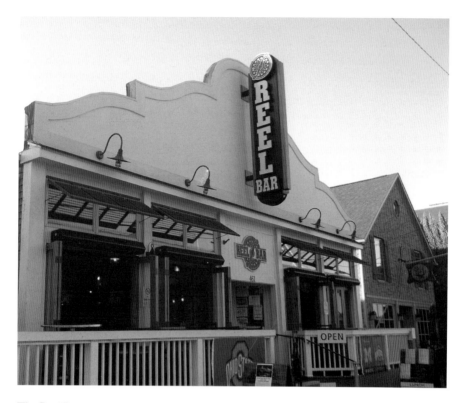

The Reel Bar as it appears today. *Photo by the author.*

as a bartender. He continued in this line until he decided to open his own place, Rehberg's, in 1906.

The site that he chose for his establishment was just on the other side of the blacksmith's shop, opposite Benny Rosenfeld's store. While it was a very simple frame construction building, it featured a rather unique Dutch-style gable on the upper façade of the structure. This gable remained largely unchanged over the years and is present to this day.

By 1920, Rehberg had withdrawn from the saloon-keeping industry and took a quieter life. He had recently lost a few fingers in an automobile accident, and it was getting harder for him to handle the tavern. He eventually chose the life of a farmer and purchased some fruit orchards farther out on Catawba Avenue. By 1930, he was doing odd jobs around town.

John Rehberg Jr. died on September 6, 1934, and was buried at Maple Leaf Cemetery on South Bass Island. For a few years after Rehberg's ownership of the saloon, it continued to operate under various owners,

always being kept as a tavern or restaurant. By 1933, the building was under the ownership of a man named Tony Traverso.

Angelo Anthony Traverso was born on June 19, 1881, in New York to parents Stefano and Madelina Traverso. The family arrived at Put-in-Bay in the very early 1890s, when tourism was at an all-time high. In 1907, Tony Traverso was married to Elizabeth Cucci. Prior to purchasing Rehberg's, Traverso worked as a salesman in an island grocery store and, for a time, even worked as a farmer growing grapes.

When he first opened up his establishment, he billed it as a cigar and soft drink place. Prohibition was still going through its death throes, and there were still very strict rules on what could and could not be served. Within a few years, however, Traverso was operating a full-scale tavern. Also working here were various members of his family, including his son, Val. He continued to operate this business as Tony's Place until sometime before his passing, which occurred on July 6, 1960.

For many years afterward, the establishment bore the name Tony's, in honor of this highly revered late citizen of the community. One of the most famous items on the menu back then was what was known as the "Tin Roof" sundae.

It was during this same era that one well-established island resident had an experience that he'll never forget. He was sitting in Tony's with three

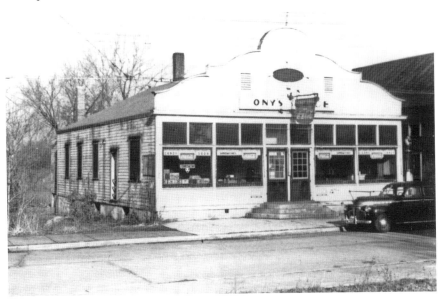

Tony's Place on Catawba Avenue, circa 1940s. *Courtesy of Maggie Beckford.*

Val Traverso pours a beer at Tony's Place. *Courtesy of Maggie Beckford.*

female companions having an enjoyable time. At one point, he glanced up into the mirror behind the bar and clearly saw what seemed to be a gray woman standing behind them. One of the other women in the group saw her as well. When they turned around to see who it was, she was no longer standing there. They quickly got up and ran to the door to catch her up, but she was gone without a trace. They could only describe her as being an elderly woman wearing gray—nothing more than that.

In its more recent years, this building was operating as Tony's Garage. Then, in 2014, it was reopened by Andy Christensen and Ray Fogg as the Reel Bar. They remodeled it to emulate the days of the island's rustic past and to celebrate the heritage of Lake Erie island living. Who knows? Perhaps the lady in gray may even stop in again to lend even more authenticity.

16

HOOLIGANS

When we think of Put-in-Bay nightlife, images of historic buildings, live music and rowdy crowds often come to mind. Most of these images seem to take us to an exotic location such as the tropics or the seaside. Believe it or not, one bar even goes as far as to take you to Ireland. It's a fact that Put-in-Bay does have one Irish pub, and that place is Hooligans.

From the moment you step inside this pub, located at 421 Catawba Avenue, you feel as though you've crossed the pond to the Emerald Isle and are sitting in one of the many fine establishments of Dublin, Wexford or Cork. Of course, they have Guinness on tap. The staff is more than happy to set you up with a perfect pint. There is also an incredible selection of Irish whiskeys to choose from, and the portions of your dinner are usually more than what you'd expect. You may need a take-home box for the fish 'n' chips. No visit would be complete without an order of Marie's apple crisp à la mode.

Guests are greeted immediately by a large front porch that runs the entire width of the building. Here, visitors are welcome to enjoy their drinks or meals in the comfort of an outdoor environment. The main room of this bar is quite spacious, but it also offers a few snugs for a more intimate experience. A seat at the bar brings kind and friendly service. Just keep the stool on the far right open. That one's reserved for island entertainment legend Pat Dailey. There's even a plaque on the bar that states this. Most every weekend night throughout the season, some of the best live music on the island can be heard here. Even on Sunday and Tuesday afternoons,

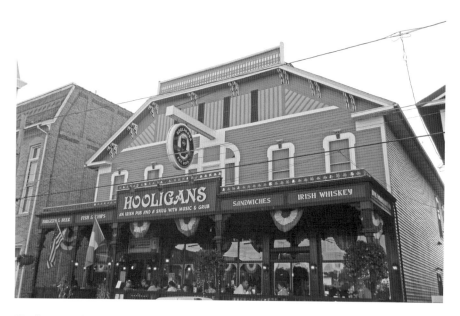

Hooligans on Catawba Avenue, which was known for many years as the Schiele Block. *Photo by the author.*

staff waitress and musician Isolde provides some of the best live Irish music the island has to offer.

What would surprise most people would be the fact that, as old as it is, this is not the first building to stand on this site. The first building to stand here was a hotel called the Bing House. This hotel was erected in the summer of 1874, but it stood for only four years. It was destroyed by a fire on August 30, 1878. That fire was started in the cupola of the first Put-in-Bay House, which sat across the street on the corner of Catawba and Delaware Avenues. A strong east wind fanned the flames, and the fire quickly spread to the surrounding buildings. In all, seven buildings in the village were lost that day.

Almost immediately after the fire, construction began on a new building to occupy the site. This was done under the supervision of the Kaebler and Stang Brewing Company of Sandusky. It was a two-story building, the lower level of which contained a saloon, which the brewery operated. Kaebler and Stang continued to run the saloon until 1884, at which time it was taken over by a man named Louis Schiele. Two years later, Schiele purchased the entire building.

Louis Schiele was born in Toledo on July 2, 1856, to parents Andrew Schiele Sr. and Justina Kirnberger. He first came to Put-in-Bay with his family

on June 20, 1865, where he would spend the rest of his life. He was married on June 15, 1880, to Anna Van Dohren, a daughter of Max and Charlotte Van Dohren, who built the press house that would one day become Joe's Bar.

Louis Schiele's father, Andrew Schiele Sr., was notably known as the man who had built the Castle, originally the Schiele home and winery but later the Castle Inn. The Castle was lost to a fire in January 1982. Louis first worked as a butcher but then decided that he would help his father with the winery and was engaged in that line of work before ultimately purchasing the saloon in town. Louis Schiele also became a member of the Independent Order of Odd Fellows, or as they were better known, the IOOF.

The local chapter of the Odd Fellows was established at Put-in-Bay in 1889. With a large hall available on the second floor of his building, Louis Schiele offered this space to the Odd Fellows to hold their meetings. This room, known as Schiele Hall, would also become the meeting place of the Rebeccas, a group of the wives, daughters and sisters of Odd Fellow members. That group was organized in 1922. Both the local Odd Fellows and Rebeccas chapters called themselves the Lone Willow Chapter. The

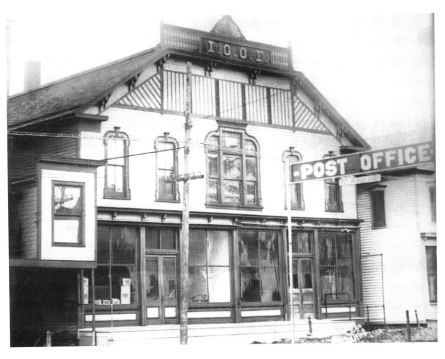

The building that would one day become Hooligans once housed the IOOF Hall, the post office and a store. The overhanging alcove on the far left was the island's telephone exchange building. *Courtesy of Hooligans.*

name was taken from the singular willow tree that had stood in De Rivera Park, which originally marked the burial site of the six fallen officers from the Battle of Lake Erie. For many years, the building was known as the Schiele Building, but it was also known as the Odd Fellows Block and had been regarded as the finest on the island.

Aside from the hall and the saloon, which was housed on the first floor, the building also held George Rittman's original grocery store and John Holloway's dry goods store. Louis's brother, Andrew Schiele Jr., would later run a propane store out of this building. Located in an overhanging alcove on the left-hand side of the structure was the island's telephone exchange.

In the fall of 1892, Louis Schiele had the building completely renovated. He hired George Gascoyne to do the work, and the results were magnificent. It now featured some ornamental designs that appeared on the outside, the focal point of which was an extremely unique second-story central window in the Queen Anne style. Above this sat an ornate cornice reminiscent of the stick style of architecture.

Louis Schiele continued to own this building until just before 1900, at which time he sold the property to J.B. Ward. After this, Schiele purchased a hotel and, aside from welcoming guests at his island lodging, also operated a free museum. Louis Schiele died on April 12, 1906, just three months shy of his fiftieth birthday.

Around 1910, Benjamin L. Smith took over the saloon, but he would run it for only a few years. In later years, the space that held this saloon would house the Put-in-Bay Post Office. For a few years it remained empty, until it was purchased in the early 1970s by the parents of June Stoiber. June explains that at this time, the building was still divided into two separate spaces. The right-hand side housed an antiques store, which her parents operated, called Heritage Antiques. The left-hand side was occupied by an art studio and gallery, which was run by a couple from the Cleveland area and featured local Cleveland artists.

As time wore on, it became more difficult for June's parents to keep up with the property, so June and her husband, George, purchased the building. Her parents continued to run Heritage Antiques from the right-hand side of the structure, while the Stoibers opened a gift shop called the Lone Willow in what had until recently been occupied by the art studio and gallery.

One winter, June Stoiber received a notification in the mail from the liquor department stating that she had finally been granted the liquor license that she'd applied for nearly twenty years earlier. This was during the mid-2000s. That year, her husband, George, began remodeling half of the building to

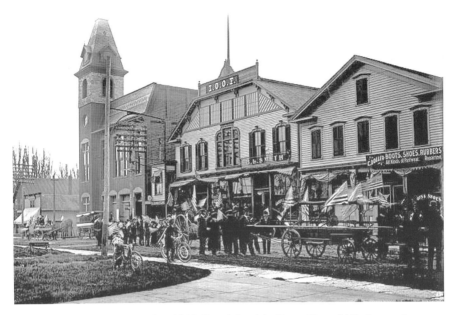

A view of Catawba Avenue, circa 1910. *From left to right:* Benny Rosenfeld's dry goods store; Put-in-Bay Town Hall; the telephone exchange building; the Schiele Block, which at this time housed the Odd Fellows Hall and Benjamin L. Smith's saloon; and Chris Doller's shoe store. This picture was taken from the corner of Delaware and Catawba Avenues, on the grounds of the newly opened Colonial. *Courtesy of Maggie Beckford.*

Members of the Lone Willow Chapter of the Odd Fellows gathered together in the upstairs hall for a toast. *Courtesy of Hooligans.*

accommodate the new bar. The following year, he opened up the rest of the building to house the entire business, which they called Odd Fellows. In 2009, the building was sold to the Booker family, and the bar was reopened that year as Hooligans.

As with most buildings of this age that carry such a storied past, there are bound to be mild disturbances here and there, the most common of these being unusual or unexplained sounds. Going just one step further, we come to the old Odd Fellows Hall, which was located on the second floor of the structure. One person who was forthcoming about this was Hooligans employee Dan Mercurio. Dan explains that late at night or sometimes even in the early evenings, going upstairs can be something of an unsettling experience. Located upstairs are the prep kitchen, dry storage and an office. Any time that he is sent up there for something, he would frequently feel many eyes upon him, almost as though the place itself were watching him, yet he knows very well that he's quite alone.

One could only imagine the gatherings that the Odd Fellows once held in that hall. Perhaps they're still up there, keeping a watchful eye on their place as well as the employees who happen to venture into their domain.

T&J'S SMOKEHOUSE

To close this tour of ghostly sites around Put-in-Bay, we finally arrive at T&J's Smokehouse. The hour is late—and much has been seen and experienced already—but there's one last stop to make. This lively barroom seems like a good place for last call, but to think, if we could take a step back in time, our rooms would be waiting for us upstairs, for T&J's had its beginnings as a grand hotel. In our day and age, an overnight stay would only be recommended for those with the stoutest of hearts and nerves of steel.

This beautiful Italianate structure was birthed in 1871, making it the oldest commercial business building in the village of Put-in-Bay. Its first owner was Andrew Hunker, father of Admiral J.J. Hunker, who occupied Inselruhe. Under this ownership, the business was called the Hunker House Hotel. Following the Hunker family's term as proprietors, the building saw a small succession of owners who would only hold it for a brief time. For a while, it was called the Ward House, when it was briefly owned by the Ward family. In 1903, it was purchased by S.T. Campbell, and the name was changed to the Detroit House.

The Campbells would only possess this property for five years. It was at that time that it was purchased by a man named T.B. Alexander.

Thomas Benton Alexander was born in Richmond, Indiana, on May 25, 1866, to parents Samuel Benton Alexander and Susan Bacon Webster. Shortly thereafter, he moved with his family to Springfield, Ohio, where he began an acting career at the age of twelve. He'd spend the next thirty years

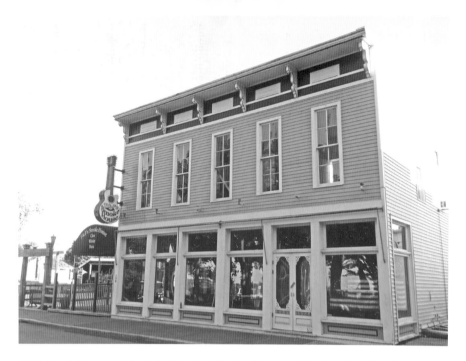

T&J's Smokehouse, originally built as the Hunker House, as it looks today. *Photo by the author.*

as a theater and stage actor, first taking on juvenile rolls and later moving on to matinee and character acting.

T.B. Alexander first came to Put-in-Bay in July 1890, where he met his future bride. He was married on September 10, 1893, at Put-in-Bay to Edith Mae Brown, who was the pianist in his theater company and also the daughter of John Brown Jr., whose father had led the raid on Harper's Ferry between the dates of October 16 and October 18, 1859. Alexander purchased the Detroit House in June 1908 and almost immediately changed the name to the Hotel Crescent. A few years later, he built a sizable addition, called the Crescent Annex, on to the east side of the building, bringing the total number of guest rooms to eighty-five, with accommodations for 150 guests. This was done to accommodate a large convention that was planned for that year.

Very interested in civic life, T.B. Alexander was a member of the IOOF and the Loyal Order of Moose. He served as mayor of Put-in-Bay from 1910 to 1913 and again from 1919 until his death.

T.B. Alexander died at Put-in-Bay at 8:00 a.m. on Tuesday, March 17, 1936, just fourteen weeks after his wife. He had suffered a stroke two

weeks earlier. He and Edith had no children, and although he was survived by three brothers, T.B. Alexander left his entire estate to Zachar Semunek, his servant of eighteen years. Of an interesting note, it was nearly a week before T.B. Alexander would take his place at his wife's side in Put-in-Bay's Crown Hill Cemetery. It was his request that he be interred in a steel burial vault. Unfortunately, the boat that was to deliver this vault could not immediately make the journey across the lake due to ice. Furthermore, the vault was too heavy to transport by airplane. Once the ice cleared, the vault was delivered and Alexander laid to rest.

Thomas Benton Alexander, 1866–1936. Actor, mayor of Put-in-Bay and proprietor of the Hotel Crescent. Many believe that his spirit still visits the former hotel. *Courtesy of Maggie Beckford.*

Following the death of T.B. Alexander, the building was purchased by E.J. Meyer, who continued to operate it as the Crescent Hotel. It was during Meyer's ownership that the grand bar was installed. This had come to the Crescent Hotel when the Laskowskis purchased the Eagle Cottage in 1946.

In the years that followed Meyer's ownership, the building was known as Herman's Bar and later as the Lighthouse Bar. It was under the ownership of the latter of these that the Crescent Annex was torn down. That site is now occupied by the Candy Bar and the patio that now sits just to the east of T&J's Smokehouse.

In 1981, the property was reopened as the Crescent Tavern by George and June Stoiber. George Stoiber always had a great respect for the building, as he worked there as a busboy when he was a kid. Upon the Stoibers purchasing the former hotel, an outside bar called the Gazebo was added to the patio, as were guest tables and an outside stage, where island entertainer Westside Steve Simmons performed regularly each summer. The Stoibers owned the Crescent Tavern until late 2011, at which time it was sold to Tim and Josh Niese, becoming T&J's Smokehouse. Now decorated in a country-western motif, T&J's

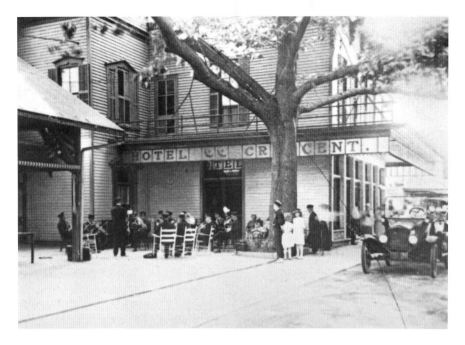

A view of T&J's Smokehouse while it operated as the Hotel Crescent under the ownership of T.B. Alexander, circa 1920s. *Courtesy of the Lake Erie Islands Historical Society Museum.*

offers a fine dining and entertainment experience to island goers. The Gazebo now bears the name the Hitching Post, and the patio boasts a mechanical bull. The barroom still carries most of the original features that were present when the building opened up as the Hunker House Hotel. Leading from the former lobby to the old hotel rooms upstairs is the original grand staircase.

Co-owner Tim Niese Jr. has a true love for island nostalgia. He hopes to bring the building back to what it originally looked like. It once had exterior features, such as a cupola, that are long gone. Also, he desires to uncover the truth as to what color it would have originally been painted.

There are more mysteries afoot at T&J's than original wall colors and lost architectural features. Tim is no stranger to these. When asked about the stories of the haunting here, he was very forthcoming with experiences.

He explained that early in the year 2012, the first year that he and his brother Josh had taken over the business, he was working inside with a couple of guys doing some light renovations. It had been fairly quiet in the building that early spring day. He had been working in what is now the dining room

and heard what sounded like someone upstairs pacing about the wooden floors. He didn't really think much about this at first. Perhaps one of the other two guys had gone up for some reason or another, he thought. A few minutes later, he walked out the back to retrieve something and found both of the men who had been working with him sitting outside. They weren't even in the building at the time he heard the footsteps.

Many people have claimed that while sitting at the front bar and looking into the built-in mirror behind it, they've seen someone walking across the room behind them. Much like what was reported at the Reel Bar when it was Tony's, they turn to find the room empty.

Most employees refuse to enter the bar at night if there aren't any lights on. They have their reasons. Every time anyone goes upstairs by themselves at night, they return with the feeling that they were not alone.

When the Niese brothers took over the establishment, there were full-sized double-hinged swinging doors in the place. These doors were quite heavy, to the point that should a strong wind blow, they would flutter ever so slightly. One time, when Tim was working in the building, he heard one of these

The bathtub on the second floor of the former hotel where it is believed a young boy drowned in the early 1900s. *Photo by the author.*

doors fully open and close. The door was too heavy to have been moved by a breeze, especially that much. Furthermore, he was the only person in the building. The most curious part about the incident was that it was just one door. All of the sets in the building were double doors.

There was one instance when his nephew was coming home from the park and pointed into an upstairs window of T&J's Smokehouse. He swore he could see someone in the window. Tim and his brother, of course, could see no one.

Back when the hotel was opened in 1871, bathtubs en suite were really something of a luxury. The Hunker House Hotel had four such rooms. Only one of these claw-foot bathtubs remain. It is said that a little boy of about four years of age drowned in this bathtub while his mother attended to another child.

Someone who was able to add to this was an employee of T&J's named Blake. He stated that one of the owner's sons had wandered upstairs shortly after they had taken over the business. When the boy's father called for him, he explained that he was playing with a boy. The father went to see who had gotten in, but the place was empty. The story of the little boy drowning in the bathtub upstairs wasn't related to them until afterward. The only other thing that Blake was able to recall was how one spring, just before the business was to open for the season, he had gone in the back room to discover that all of the labels on the shelves were now strewn about the floor. He offered no explanation for this.

Another person who has had an experience with this little boy is Kelsey Arnold, a bartender at T&J's. One time, while she was making her way toward the ladies' room, she was passing the door to the men's room when she heard a little boy in there giggling and playing with the hand dryer. The staff have started to refer to this little boy as Petey. The hand dryer in that restroom turns on quite frequently. This has been witnessed by many employees.

On another occasion, Kelsey was cleaning the patio bar at the end of the evening and had been carrying some dishes into the back room. The light to this room was turned off, but she could definitely see a dark, shadowy figure ahead of her. Though she could make out no definite features, she was certain that it was the figure of a man.

Someone else who had a couple of stories to share about T&J's was John Domer, whom we met a few times on this island tour. John explains that in his lifetime, T.B. Alexander was a bit of a prankster and a vain man. Both of the stories that John Domer relayed played into these aspects of Alexander's life.

Back when John was working at Pasquale's, a girl came in inquiring about a job there. Until recently, she had been working for the Stoiber's at the Crescent Tavern—primarily as a breakfast server—but on occasion would work the dinner crowd. She was looking for a change in employment because recently she had gotten quite spooked. The previous night after closing, the staff was getting the place ready to handle the breakfast rush in the morning. This entailed setting out the placemats, silverware, creamers, packets of jellies and napkins. All in all, the job usually took between fifteen and twenty minutes to complete. Aside from her, the only other person in the building was closing up in the kitchen. She was almost finished when she realized that she needed more napkins. She walked into the back to grab some and returned to the dining room to find the tables cleared and every item she had just set put back to where it normally was kept stored. Again, the only other

One of the posters in room 8 of the former Hotel Crescent. This one depicts T.B. Alexander in the role of King Rudolf from *The Prisoner of Zenda*. *Photo by the author.*

person present was in the kitchen. Had someone gone out and done this, he or she would have had to walk right past her. What's more is that it would have taken someone closer to ten minutes to have accomplished this. She had only been out of the room for about thirty seconds. At this, she said good night to the person in the kitchen, added that she wouldn't be back and, with that, left.

The other story John Domer related concerns an upstairs room in the front of the building. This room had been the personal bedroom of T.B. Alexander. He chose it so that he could look down on his business and keep an eye on things. Here Alexander had glued posters from his former life as an actor upon the walls. It is said that shortly after the Stoibers took over the building in the early 1980s, George Stoiber had a thought to convert the former hotel rooms into employee housing. To give the place a fresh appearance, he painted all of the rooms upstairs. When he came to the room

with the posters, he painted over them as well. Within a few days, the paint over the posters had peeled off. Next he tried to prime the walls first and then paint them. Again, the paint peeled off just days later. Next he tried to put drywall over them, but that, too, fell off. He even went as far as to put shelves over these posters and simply convert it into an office. It wasn't long before the shelves began to fall. It was ultimately decided that the shelves would be placed around the posters and they would continue to be displayed. That is how the room stands today.

As mentioned in the chapter on Joe's Bar, Hippie Jerry worked at the Lighthouse Bar, which was housed in the former Hotel Crescent. During this time, he lived in what was then room 8 upstairs. This was the same room that contained the posters of T.B. Alexander. Most of Jerry's friends felt a little uncomfortable in there and refused to go into that room, which was fine with him. Of T.B. Alexander, Jerry says that he used to wear a pair of pearl-handled derringer pistols on his side while he was the mayor. He was also the only constable at Put-in-Bay at the time. Back then, it was rare to require extra help when enforcing the law. Everyone had the utmost respect for him.

One person who may have spent more time at T&J's than any other is Bret Klun, who used to work there when it was the Crescent Tavern. He first started working there in 1993 at the age of eighteen. He was hired to work as a dishwasher but also helped out once a week with janitorial services. He also checked IDs at the door on Friday and Saturday nights and would frequently be there very late at night. He returned the following year to work, among so many other things, as a cook. When he came back in 1995, he was made the bar manager and, within two years, had been promoted to general manager. Here he remained until the end of the 2011 season, at which time the business was sold to Tim and Josh Niese. He is now the manager at the Keys.

Bret Klun says that he had never heard the story about the attempt to cover the posters of T.B. Alexander and has his doubts about it. George Stoiber, he believes, would never try to conceal such a huge part of that place's history. He has, however, heard the story about the little boy drowning in the bathtub upstairs. Quite possibly everyone's heard about that by now. Aside from those, Bret had many other stories to share.

Of course the place can be quite spooky when closing down for the night. All sorts of sounds are to be heard from the upstairs, creaking doors and whatnot. One experience that was related to him by the janitor shortly after he started working there was a story about cleaning behind the bar. One night, while performing this task, the janitor glanced up into the large mirror

that was mounted behind the bar and noticed that a man had pulled up a stool and seemed to be waiting for service. The janitor informed him that they were closed and he couldn't be in there after hours. With that, the janitor returned to his work. A moment later, he realized that the man hadn't left. At this point, the janitor turned to repeat himself to the man, but just like that, the late-night visitor had vanished.

This stranger was described as being somewhere in his late sixties or early seventies. He'd been wearing an older suit, which in itself seemed quite odd, considering that it was the middle of summer and quite warm outside. Some time later, the janitor discovered the posters on the wall upstairs and recognized T.B. Alexander as the same man who had been in the bar that night.

A couple of years after becoming the manager, Bret had an international student come to work for him as a janitor. One night, while mopping the floors and moving tables around, he heard a banging sound from behind him and turned to discover that one of the tray stands had been set up in the middle of the room. This was his first week on the job, and he hadn't heard any of the stories regarding the haunting of that place. Assuming that someone was messing with him, he folded up the tray stand and returned it to its rightful place across the room about fifteen feet from where it had been suddenly set. He returned to his work, but about ten minutes later, he heard the banging sound again. He turned to discover that the tray stand was set back up again in the middle of the room. Again, he picked it up and stowed it away against the wall. A little over an hour later, while cleaning the other side of the room, it happened again. At this, he set down his mop and left the building.

Bret's office was originally at the south end of the upstairs hallway. This room, however, would get quite hot during the summer months. It had something of a close feeling to it. Eventually, he moved his office to the north end of the hallway and into the room where T.B. Alexander's posters are glued to the wall. On occasion, he would hear a tapping sound at the window, but knew it was impossible for someone to be up there messing with him. The windows here sit twenty feet off the ground. He'd also hear footsteps and doors closing, but it was nothing aggressive—quite the opposite, in fact. He actually felt pretty relaxed at this end of the building.

Where his office had formerly been located, at the south end of the building, he'd placed a loveseat. One night, just after the huge annual Christmas in July celebration that brings throngs of people to the island, he decided to lie down on this loveseat and take a quick nap. This was around ten o'clock in the evening. Close to this office was a door that was kept closed

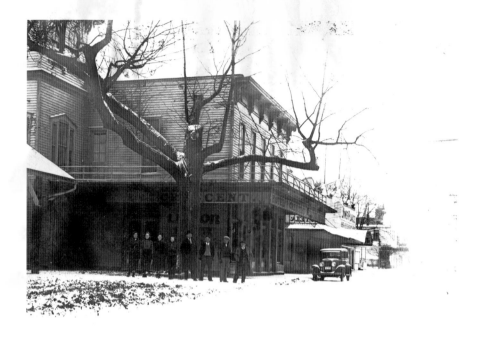

The Hotel Crescent during a 1930s winter. *Courtesy of Maggie Beckford.*

by a large spring. As he was dosing off, he heard this door open and close but thought nothing of it. For all he knew, someone had gone down the hallway to retrieve something. A moment later, he heard the door slam again. At this, he decided to investigate. He looked but could see no one present. He lay back down, and the door banged five more times, quite aggressively. He could definitely feel a difference in the comfort levels between his office at the north end of the building and the south end. Something in the south end just didn't seem very happy.

Sometimes at the end of the night, the staff would be out back breaking down boxes for disposal. On occasion, one of them would look up and see someone looking out the south windows from above. Somebody would always have to go and check it out, but each time they would come back disappointed, as there was no one there.

One of the other unusual reports is of a blue light that can be seen at that end of the building. This has been reported from both sides of the property, even at a time when there was no electricity running to those rooms.

Bret Clun, personally, hasn't ever seen a ghost in that place but certainly has had the hair stand up on the back of his neck and the chills come out of

nowhere. He's felt extreme temperature differences throughout the building and has also felt the comfort of the front of the building as well as the discomfort of the back.

Looking back on our tour, we've seen lighthouses, monuments, lodgings and saloons, all of which have their own stories to tell. Of course there are more places than those discussed here, where phantoms tread through empty rooms and items move about of their own accord. These are just the most prevalent. So, the next time you feel the urge of wanderlust, coupled with a desire to experience the paranormal, consider a trip to the small island community of Put-in-Bay, Ohio. Who knows what you might discover?

BIBLIOGRAPHY

Altoff, Gerard T. *Oliver Hazard Perry and the Battle of Lake Erie*. Put-in-Bay, OH: Perry Group, 1999.

Bowland, James Mitchell. *Pioneer Recollections of the Early 30's and 40's in Sandusky County, Ohio*. N.p.: Muchmore & Son's Print, 1896.

Canton (OH) Repository. March 23, 1936; July 30, 1945.

Chronicle Telegram (Elyria, OH). August 13, 1972.

Cleveland (OH) Leader. June 1, 1874; August 31, 1878.

Cooper, Susie. *Crown Hill Cemetery*. Put-in-Bay, OH: Lake Erie Islands Historical Society, 2010.

Cruickshank, Nancy. "South Bass Island Lighthouse." Ohio Seagrant Commission FS-079, 1999.

Dodge, Robert J. *Isolated Splendor: Put-in-Bay and South Bass Island*. Hicksville, NY: Exposition Press, 1975.

The Firelands Pioneer. Firelands, OH: Firelands Historical Society, 1882.

Frohman, Charles E. *Put-in-Bay: Its History*. Columbus: Ohio Historical Society, 1971.

Gora, Michael. *Lake Erie Islands: Sketches and Stories of the First Century After the Battle of Lake Erie*. Put-in-Bay, OH: Lake Erie Islands Historical Society, 2004.

Hardesty, L.Q. *Illustrated Historical Atlas of Ottawa County, Ohio: From Recent and Actual Surveys and Records*. Chicago: H.H. Hardesty, 1874.

Koile, Wendy. *Disasters of Ohio's Lake Erie Islands*. Charleston, SC: The History Press, 2015.

Lake Erie Islands Historical Society. *Put-in-Bay Souvenir Tour Book*. Put-in-Bay, OH: Lake Erie Islands Historical Society, 2010.

Langlois, Thomas Huxley and Marina Holmes Langlois. *South Bass Island and Islanders*. Columbus: Ohio State University, 1948.

Ligibel, Ted and Richard Wright. *Island Heritage: A Guided Tour to Lake Erie's Bass Islands*. Columbus: Ohio State University Press, 1987.

Martin, Jessie A. *Beginnings and Tales of the Lake Erie Islands*. Detroit, MI: Harlow Press, 1990.

New York Times. March 26, 1896.

Plain Dealer (Cleveland, OH). August 28, 1874; February 20, 1978; October 4, 1888; September 3, 1905; May 16, 1914; November 25, 1914; May 16, 1926; January 15, 1933; June 19, 1938; June 18, 1939; July 28, 1945; August 30, 1948; February 16, 1964; June 12, 1966; September 17, 1967; September 24, 1971.

Ryall, Lydia Jane. *Sketches and Stories of the Lake Erie Islands*. Perry Centennial Edition. Norwalk, OH: American Publishers, 1913.

Sandusky (OH) Daily Register. July 9, 1873; September 16, 1873; April 9, 1890; April 15, 1890; July 21, 1890; March 18, 1891; October 27, 1892.

Sandusky (OH) Register. September 9, 1911; July 23, 1965.

Sandusky (OH) Star. September 2, 1898; September 3, 1898.

Sandusky (OH) Star Journal. June 10, 1911; November 10, 1919; October 21, 1919; April 26, 1921; May 2, 1921.

Thorndale, Theresa. *Sketches and Stories of the Lake Erie Islands*. Sandusky, OH: I.F. Mack & Brother, 1898.

Waffen, Chad. *Ohio's Lake Erie Islands: A Brief History in Words and Pictures*. Bay Village, OH: Westfalia Publishing Group, 2006.

ABOUT THE AUTHOR

Courtesy of George F. Krejci

William G. Krejci was born in Cleveland, Ohio, in 1975 and raised in the neighboring suburb of Avon Lake. With an interest in local history, he spends much of his time debunking urban legends of northern Ohio and works as a seasonal park ranger at Perry's Victory and International Peace Memorial at Put-in-Bay, Ohio. During the off season, he resides in Cleveland. In 2015, he released *Buried Beneath Cleveland: Lost Cemeteries of Cuyahoga County* (The History Press, 2015), which tells the stories of over fifty displaced cemeteries throughout the greater Cleveland area. He is also the author of the Jack Sullivan Mysteries and has been a guest speaker at many various local historical societies, libraries, bookstores and civic groups. In his free time, he plays guitar and sings in an Irish band.

He is also the coauthor of an upcoming book about Cleveland's notorious Franklin Castle, which is regarded as the most haunted house in Ohio. This book marks the culmination of twenty-five years of research into that legendary house.

Visit us at
www.historypress.net

··

This title is also available as an e-book